ON EVERY WALL

PRAISE FOR OTHER BOOKS BY BEN GOLDMAN

The Truth About Where You Live (Random House/Times Books, 1992)
"Helpful to anyone wanting to be fully informed about toxic threats"
— Vice President Al Gore.
"Embodies the promise and problems of citizen activism on health"
— *Journal of the American Medical Association*.
"Civil rights groups should use this information in their fight for environmental justice" — Rev. Dr. Benjamin F. Chavis, Jr.
"A landmark new book" — *Longevity Magazine*.
"Deserves to be a best-seller" — Dr. Vicente Navarro, Johns Hopkins University.

Deadly Deceit (with Jay M. Gould, Four Walls Eight Windows, 1990)
"A frightening, powerful report" — *The New York Times*.
"Should be read by every person concerned about health"
— Dr. Linus Pauling, Nobel Laureate.
"Impressively documented. A powerful report" — *Publishers Weekly*.

Hazardous Waste Management (with James Hulme & Cameron Johnson, Island Press, 1986).
"An indispensable addition to the discussion of hazardous waste"
— New Jersey Governor James Florio.
"Will help governments and corporations improve hazardous waste management" — U.S. Senator Robert T. Stafford.

Toxic Wastes and Race (with Charles Lee, United Church of Christ Commission for Racial Justice, 1986)
"It is not an overstatement to say that Dr. Goldman's work ignited the environmental justice movement in the United States." — Dr. Sheldon Krimsky, Tufts University.

ON EVERY WALL

REPRODUCTION AND THE FUTURE OF ART

by

BENJAMIN A. GOLDMAN

First Published March 2017 by

United Visual Arts LLC

www.nextartmovement.com

Copyright © 2017 Benjamin A. Goldman

All rights reserved.

ISBN: 978-1-5450-3983-0

TABLE OF CONTENTS

Reproduction: **Past, Present, Future** ..1
Reproduction: **A Democratic Impulse** ..4
Reproduction: **Intransigent Hierarchies** ..7
Reproduction: **Opening the Floodgates** ...10
Reproduction: **Limiting the Print Frenzy** ...13
Reproduction: **Its Opposite is Extermination** ..15
Reproduction: **At the Core of Postmodernism** ..17
Reproduction: **Identity and Biology** ...21
Reproduction: **Celebrity and Survival** ..29
Reproduction: **The Myth of Overexposure** ...33
Reproduction: **Still Second Class** ...40
Reproduction: **The Secret is Out** ..45
Reproduction: **Slow Motion Technicolor** ..50
Reproduction: **Spawning the Unexpected** ..57
Reproduction: **A Political Formula** ..61
Reproduction: **Social Sculpture for the Creative Economy**68
Reproduction: **Genesis of the Next Art Movement**74
Reproduction: **Bountiful Opportunity** ...78
Reproduction: **The Future of Art** ..85
References ..92

LIST OF REPRODUCTIONS

1. **Gallery of Hands.** ca. 30,000 BC. .. 5
2. **The Diamond Sutra.** 868 AD. .. 6
3. **Albrecht Dürer.** Woodcut to Chapter 52 of Sebastian Brant's Das Narrenschiff. 1494. .. 6
4. **Albrecht Dürer.** Man Drawing a Reclining Woman. 1538. 6
5. **Death of William Tyndale (1536).** 1563. .. 9
6. **Giorgio Vasari.** Title Page, Lives of Artists. 1550. 9
7. **Rembrandt Harmensz van Rijn.** Beggar Leaning on a Stick. ca. 1630. .. 9
8. **Katsushika Hokusai.** Kohada Koheiji. ca. 1830. 11
9. **Theodore Maurisset.** Daguerreotypemania. 1839. 11
10. **Jules Chéret.** Palais de Glace - Jeune Fille. 1894. 11
11. **Pierre Bonnard.** Poster for La Revue Blanche. 1894. 11
12. **Henri de Toulouse-Lautrec.** Divan Japonais. 1893. 11
13. **Edgar Degas.** l'Etoile ou Danseuse sur scène. 1876-1877 12
14. **James McNeill Whistler.** Agnes. 1873/1878. 14
15. **Jean-Auguste-Dominique Ingres.** Odalisque. 1825. 14
16. **Sidney B. Felsen.** Daniel Buren at Gemini workshop. 1988. 14
17. **Procter & Gamble Co.** I Thought I Was Doomed To Dull, Unattractive Hair Until I Tried Drene. 1937. 16
18. **Mikhail Troitskii.** Poema o Mashiniste (Poem about the machine operator). 1932. .. 16
19. **Coco Robot Studios.** Che-Britney. ca. 1999-2002. 16
20. **Marcel Duchamp.** Fountain. 1917. ... 19
21. **Pablo Ruiz Picasso.** Les Demoiselles d'Avignon. 1907. 19

22. **Nkanu Mask**. nd. .. 19
23. **Jean-Auguste-Dominique Ingres**. Venus Anadyomène. 1848. 19
24. **Andy Warhol**. Marilyn Diptych. 1962. ... 19
25. **Joseph Beuys**. I like America and America likes Me. 1974. 20
26. **Constantin Brancusi**. Endless Column. 1937-38. 20
27. **Donald Judd**. 100 untitled works in mill aluminum. 1982-1986. .. 20
28. **Robert Smithson**. Spiral Jetty. 1970 ... 20
29. **Jeff Koons**. Three Ball Total Equilibrium Tank. 1985. 20
30. **Jean Michel Basquiat**. Mona Lisa. nd .. 20
31. **Felix Gonzalez-Torres**. Untitled (Perfect Lovers). 1987-1990. 20
32. **David Adamson**. Chuck Close Inkjet Self-Portrait Being Prepared. nd .. 20
33. **Janine Antoni**. Gnaw (detail). 1992. .. 25
34. **Judy Chicago**. A Chicken in Every Pot. 1998. 25
35. **Kathy Grove**. The Other Series: After Lange. 1989-1990. 25
36. **Guerrilla Girls**. Women in America Earn Only 2/3 of What Men Earn. Women Artists Earn Only 1/3. 1985 25
37. **Hannah Hoch**. Made for a Party. 1936. ... 25
38. **Jenny Holzer**. Xenon Projection. 2000 ... 25
39. **Barbara Kruger**. Untitled (I shop therefore I am). 1987. 26
40. **Sherrie Levine**. Fountain (after Marcel Duchamp: A.P.). 1991 26
41. **Bridget Riley**. Breathe. 1966. .. 26
42. **Faith Ringgold**. Flag Story Quilt. 1985. .. 26
43. **Miriam Schapiro**. Mother Russia (fan). 1994. 26
44. **Cindy Sherman**. Untitled #205. 1989. ... 26
45. **Laurie Simmons**. Untitled. 2002. .. 26
46. **Lorna Simpson**. Wigs (Portfolio). 1994. .. 26
47. **Kara Walker**. Jockey. 1995 .. 26
48. **The Bayeux Tapestry**. 1073-1083 .. 27
49. **Karen Finley**. 1-900-ALL-KAREN. 1998. .. 27
50. **Robert Mapplethorpe**. Self Portrait. 1985. .. 27
51. **Chris Ofili**. The Holy Virgin Mary. 1996. .. 27
52. **Andres Serrano**. Piss Christ. 1989 ... 27
53. **Medieval Etching (not Trotula). nd** ... 27
54. **Brandon Ballengée**. Cleared and Stained Multi-limbed Pacific Tree frog. 2002. ... 27

55. **Natalie Jeremijenko**. OneTrees Project. November 1998 - March 1999. 28
56. **Eduardo Kac**. Alba (fluorescent bunny). 2000. 28
57. **Andrea Fraser**. Still from Untitled. 2003. 28
58. **Larry Wachowski** and **Andy Wachowski**. Matrix Revolutions. 2003. 31
59. **Charlie Chaplin**. Modern Times. 1936. 32
60. **King James Bible**. Genealogy 1. 1611. 32
61. **Mad Editors**. The QWERTY Mad. 1991. 38
62. **Pablo Ruiz Picasso**. Boy with a Pipe. 1905. 39
63. **ARTnews**. Cover: Great Underrated Artists. 2005. 39
64. **Rolling Stone**. Cover: 500 Greatest Songs of All Time. 2004. 39
65. **William Congdon**. La Madonna Del Presepio. 1984. 39
66. **Bruce Nauman**. Henry Moore Bound to Fail. 1967. 39
67. **Jan van Eyck**. Portrait of Jan De Leeuw. 1436. 39
68. **Ronald Reagan**. Testifying before the House Un-American Activities Committee as President of the Screen Actors Guild. 1947. 39
69. **Graham Nash**. Self-Portrait at the Plaza Hotel, New York. 1974. 44
70. **Thomas Kinkade**. In the Garden of Hope. 2005. 44
71. **Vitaly Komar** and **Alex Melamid**. United States: Most Wanted Painting. 1995. 44
72. **Hayden Lambson**. Clear Landing (Ducks Unlimited Catalogue Cover). 2004. 44
73. **Tony Pritchett**. Flexipede. 1968. 55
74. **Assume Vivid Astro Focus**. Garden IV wallpaper and y.o floor sticker. 2003. 56
75. **Michael Rees**. Putto 4 over 4. 2004. 56
76. **Do Not Touch**. nd. 56
77. **David Hockney**. Chair, Jardin de Luxembourg, Paris. 1985. 56
78. **Eric Adigard**. Absolut Adigard. 1996. 56
79. **Anthony Mandler**. The Remix Masters. 2004. 60
80. **Damien Hirst**. Opium. 2000. 60
81. **Save Martha Poster**. nd. 65
82. **Louise Bourgeois**. You and Me 1. 2004. 65
83. **Nam June Paik**. Global Groove. 2004. 65

84. **David Salle**. Have a wonderful trip. 2004. ... 65
85. **William Wegman**. Trio. 2004. ... 65
86. **Prize Budget for Boys**. Pac-Mondrian. 2002. 65
87. **James Buckhouse**. Tap. 2002. .. 66
88. **Cory Arcangel (aka Beige)**. Nipod. 2005. .. 66
89. **®™ARK**. The Barbie Liberation Organization. 1993. 66
90. **Alec Thibodeau**. Noney. 2004. ... 66
91. **Peter Walsh**. Celebration of the Reversal the New Croton Aqueduct. 2001. ... 66
92. **Anissa Mack**. Pies for a Passerby. May 17 - June 23, 2002. 66
93. **Zoë Sheehan Saldaña**. Secret Treasures Peasant Boxer Set (Blue Print). 2003. ... 66
94. **Harrell Fletcher**. This Container isn't Big Enough. 2004. 67
95. **Takashi Murakami**. The Double Helix Reversal. 2003. 67
96. **Takashi Murakami**. Louis Vuitton Murakami Multicolor Speedy 30 handbag. 2003. .. 67
97. **Maurizio Cattelan**. La Nona Ora (The Ninth Hour). 1999. 73
98. **S.C. Johnson & Son Inc**. Glade® Holiday Candles. 2004. 73
99. **Christo** and **Jeanne Claude**. The Gates, Project for Central Park, New York City. 2002. ... 84
100. **Danny Tisdale**. An Artist for a Change in New York City. 1996. .. 91
101. **Bill Watterson**. Calvin and Hobbes. 1990. 91
102. **Joseph Beuys**. Kunst = Kapital (Art = Capital). 1980. 91

Note: all plates are available as full-color images at
www.oneverywall.com

Reproduction: Past, Present, Future

"A man paints with his **brains** and not with his hands." – *Michelangelo*

> "[T]he earliest art works originated in the service of a ritual—first magical, then the religious kind…. [T]he unique value of the 'authentic' work has its basis in ritual…. [F]or the first time in world history, mechanical reproduction emancipates the work of art from its parasitical dependence on ritual. From a photographic negative, for example, one can make any number of prints; to ask for the 'authentic' print makes no sense. But the instant the criterion of authenticity ceases to be applicable to artistic production, the total function of art is reversed. Instead of being based on ritual, it begins to be based on another practice—**politics**." – *Walter Benjamin* [1]

"I'm interested in the distribution of physical vehicles in the form of editions because I'm interested in spreading ideas. The objects are only understandable in relations to my **ideas**. The work I do politically has a different effect on people because such a product exists than it would have if the means of expression were only the written word. Although these products may not seem suitable for bringing about political change, I think more emanates from them

[1] Benjamin 1935.

than if the ideas behind them were revealed directly. To me the vehicle **quality** of the editions is important...." – *Joseph Beuys* [2]

> "I like things to be exactly the same over and over again. I don't want it to be essentially the same—I want it to be **exactly the same**."
> – *Andy Warhol* [3]

"A painting's meaning lies not in its origin, but in its **destination**." – *Sherrie Levine* [4]

In contemporary America, and with global reach, culture has been redefined as intellectual property. This is the only game in town. Multinational corporations are the dominant players, absorbing and provoking counter-cultures and traditional cultures alike. The rules are inordinately complex, involving worldwide legal systems that only an army of experts can decipher. The action is connected by chaotic technological infrastructures that simultaneously reduce all cultural production into a single digital currency, while unleashing infinite possibilities for creative expression. Reproduction—be it virtual or physical—is the ultimate prize: the primary mode by which creators communicate their contributions to a larger audience and capture the full value of their work.

Technological revolutions spur new opportunities and new limits, pioneers and resistance. These effects are extreme in the fine arts, with its contradictory values of innovation and tradition, fame and rarity, originality and universality, subversion and awe. Will the digital reproduction of ideas—in the form of images, words, sounds, movement, and numbers—have as profound of an effect in the Twenty-First Century as the invention of mechanical reproduction had in the Fifteenth Century? Will visual artists be at the cutting edge of these changes as they

[2] Beuys 1970.

[3] Warhol 1989.

[4] Levine 1982.

were six-hundred years ago? The answer lies in how creative professionals engage the world of intellectual property and communicate to the public at large.

Western society has evolved over centuries toward ever more liberal conventions of cultural access, but each generation must repeat the struggle. With every advance in the reproductive dissemination of cultural creation comes a conservative reaction that longs for older traditions, and tries to reign in the effects of technologically wrought change. Artists have played leading roles on both sides of this historical debate. Digital reproduction is at the heart of today's tussle of cultural evolution. While important aspects of digital reproduction are new, many of the tensions posed are ancient in origins.

Reproduction: A Democratic Impulse

Within a few decades of the death of Johannes Gutenberg (1397-1468), and just a few towns over, Albrecht Dürer (1471-1528), the son of a goldsmith, elevated the humble woodcut from a simple tool for printing playing cards and devotionals to the level of artistic masterpiece. Dürer's accomplishment rested on an ancient history of art reproduction. Some of the earliest art known to man are 25,000-year-old stenciled hand prints [**PLATE 1**] on the walls of Pyrenees caves. [1] In ancient Greece, founding and stamping was used to reproduce art on coins, bronzes and terra cottas.[2] The earliest relief prints came with the invention of paper in China (105 a.d.). Stone rubbings, stenciling, and eventually woodcut prints spread Buddhism throughout Asia, including the earliest dated printed book from 868 a.d., called the *Diamond Sutra* [**PLATE 2**], an illustrated Buddhist scroll. The Chinese invented moveable clay type by 1041.

In 1436, six centuries after the *Diamond Sutra* was printed, Gutenberg built the first press with replaceable wooden or metal letters. What Mark Twain calls "the incomparably greatest event in the history of the world" is widely credited with igniting the Renaissance and causing the most profound cultural and sociological change. Until then, books—the Bible and Torah in particular—were rare objects, treasured symbols of elite

[1] Paglia 2004; Wisniowski 2003.

[2] Benjamin 1935.

wealth, power, and literacy. Within a century, tens of millions of books were distributed throughout Europe; printed words and images were no longer the sole domain of nobility and clergy. Mechanical reproduction shook the foundations of religious authority with its enlightening and democratizing effects for the emerging merchant classes.

Dürer's first commission was to illustrate Sebastian Brant's *Das Narrenschiff* (*Ship of Fools*) **[PLATE 3]**, published in 1494 by Johann Bergmann de Olpe. This illustrated manuscript became the Western World's first bestseller, with multiple editions and translations into all European languages. Dürer's prints anticipate many of the sensibilities and artistic concerns of our postmodern, digital age. He participated in one of the first mass market phenomena, experimented with a far-reaching new technology, and created such symbolically complex and self-conscious woodcuts as *der Messung* (*Work about the Art of Drawing*, 1538) **[PLATE 4]**, which encourages speculation about reality and simulation, gender and creativity, gaze and frame, difference and domination.[3]

Gutenberg's invention marks the exact midway point of the twelve centuries between our age of digital reproduction and the first printed book. It is remarkable to consider that the democratic, anti-elitist impulse of reproduced words and images has been there from the start—even if motivated by religious belief. The world's first public domain notice was clearly printed on the last page of the *Diamond Sutra*: "reverently made for universal free distribution by Wang Chieh on behalf of his two parents on the 15th of the 4th moon of the 9th year of Hsien-t'ung."[4]

PLATES

1. **Gallery of Hands.** ca. 30,000 BC.
Panel of Hand Stencils at the Cave of Chauvet-Pont-d'Arc that were created by blowing pigments onto a hand placed against the wall. The black profile is a mammoth walking to the left (back, forehead, trunk). It was drawn after the hand. Courtesy of the French Ministry of Culture and Communication.

[3] Felluga 2003; Wolf 1990.

[4] Carter 1925.

http://www.culture.gouv.fr/culture/arcnat/chauvet/en/index.html

2. **The Diamond Sutra**. 868 AD.
The world's earliest printed book. Courtesy of The British Library.
http://www.chinapage.com/print1.html

3. **Albrecht Dürer**. Woodcut to Chapter 52 of Sebastian Brant's Das Narrenschiff. 1494. Johann Bergmann de Olpe, Basel. Reprinted in and courtesy of The Complete Woodcuts of Albrecht Dürer, ed. Willi Kurth (New York: Dover, 1963).
http://www.sla.purdue.edu/academic/engl/theory/assets/images/luchre.gif

4. **Albrecht Dürer**. Man Drawing a Reclining Woman. 1538.
From the second edition of Underweysung der Messung (Work about the Art of Drawing). Originally printed in Nuremberg. Reprinted in and courtesy of The Complete Woodcuts of Albrecht Dürer, ed. Willi Kurth (New York: Dover, 1963).
http://www.vanedwards.co.uk/month/jul99/month.htm

Reproduction: Intransigent Hierarchies

Resistance from reigning elites has usually accompanied the democratic possibilities of advances in reproduction technologies. William Tyndale (1494-1536) [**PLATE 5**] was born the same year that *Ship of Fools* was published. Exactly one century after Gutenberg's invention, Tyndale was burned at the stake for attempting to publish the first English translation of the Bible in Britain.

Privileged opposition to the printing press was widespread from the outset, ranging from disdain to censorship to far worse. Libraries and their patrons favored hand-copied Latin manuscripts; scholars praised the aesthetic and spiritual qualities of handwritten codices.[1] Such deep attachments to the purity of hand-made arts and traditional modes of communication echo throughout the ages. The most sophisticated gatekeepers of "high culture" typically have frowned on new technologies and more popular styles of expression that promise greater public access and appreciation.

Painting and sculpture were regarded as manual crafts in the Western World until the Renaissance, when the status of such visually accessible creations was finally elevated to the level of arts alongside poetry and music.[2] Giorgio Vasari (1511-1574) helped establish the prominence of painters, sculptors and architects with his *Lives of Artists* (1568) [**PLATE 6**], but continued to dismiss woodcuts and other printmaking techniques, and certainly any print not made by a painter's hand.[3] The same prejudice

[1] Keating and Hargitai 1999.

[2] Witcombe 1997.

[3] Wyckoff 2000, p. 15.

is integral to the structure of the visual art market to this day, with *New York Times* critic Michael Kimmelman calling prints, "the proverbial stepchild" of the visual arts.[4] Originality, authenticity, provenance, rarity, and quality are the hallmarks of value in fine art. This is a profoundly political equation. The flip side is at the core of Walter Benjamin's seminal 1935 article, "The Work of Art in the Age of Mechanical Reproduction," which has become so influential that contemporary art guru David Ross quips, "it seems everyone is required to quote from [it]."[5]

By the end of the Renaissance, the lowly status accorded printmaking by the Guild of Holland was precisely why Rembrandt van Rijn (1606-1669) **[PLATE 7]** began etching. Working in a medium at the periphery of established artistic concern freed him to experiment outside of academic controls and dogma. Rembrandt's exclusive relationship with his publisher and dealer Hendrick van Uylenburgh is emblematic of the significance of printing to his life as an artist. Rembrandt not only lived in Uylenburgh's home for years, but even married Uylenburgh's cousin Saskia, the subject of many Rembrandt masterpieces.

Rembrandt's lifetime marks the birth of licensing in the West, which began as a means for censuring "naughty printed books" (as stated in Henry VIII's proclamation of 1538) and protecting the interests of church, state, and a small oligopoly of commercial printers.[6] "The contractual association between artist and publisher was at the heart of the printmaking enterprise and represents an essential pattern of early licensing," according to legal scholar Brooke Oliver."[7] In 1662, the King of England decreed the first European licensing act, and in 1710, the Statute of Anne was passed, becoming the first copyright act in the world. Controlling the reproduction of words and images was paramount, as interest in such forms of expression was not quelled by hierarchical standards and bias alone.

[4] Kimmelman 2005.

[5] Ross 1999.

[6] Unwin, Unwin and Tucker 2004.

[7] Oliver 2004.

PLATES

5. **Death of William Tyndale (1536).** 1563.
On a platform before castle walls, Tyndale ("Lord opé the king of Englands eies"), in a loin cloth, is chained to a stake by an executioner; a large crowd of soldiers, monks, and civilians look on. Series 3 (2nd) Implied Book, Friars, one gesturing with hand Loinclothed martyrs, incl. Jerome of Prague. John Foxe. Actes and Monuments of These Latter and Perillous Dayes, Touching Matters of the Church ("Foxe's Book of Martyrs"). John Day, London, 1563. Courtesy of Ohio State University Library.
http://dlib.lib.ohio-state.edu/foxe/

6. **Giorgio Vasari.** Title Page, Lives of Artists. 1550.
From The Lives of the Most Excellent Painters, Sculptors and Architects. Florence. Courtesy of The Australian National University.
http://easyweb.easynet.co.uk/giorgio.vasari/

7. **Rembrandt Harmensz van Rijn.** Beggar Leaning on a Stick. ca. 1630.
Etching, 3-3/8 x 1-7/8 in. (8.6 x 4.8 cm); sheet: 3-1/2 x 2 in. (8.9 x 5.1 cm). Courtesy of the Metropolitan Museum of Art.
http://www.metmuseum.org/toah/hd/rembp/hob_26.72.156.htm

Reproduction: Opening the Floodgates

Rembrandt may be remembered today primarily as a great painter, but etchings are what first made him famous throughout Europe.[1] Prints were a way to sell art to a larger market than could afford to buy or travel to view an original oil painting.[2] Rembrandt biographer Gary Schwartz argues "it was Rembrandt the etcher who most palpably changed the history of art."[3] Rembrandt produced 300 etchings, and his plates were printed upon over and over again under his supervision and long after his death.[4] But this master's prolificacy represents just the beginning of the more widespread distribution of art to come.

Within a hundred years of Rembrandt's death, a young Japanese artist would begin work raising the level of artistic reproduction by two orders of magnitude. Katsushika Hokusai (1760-1849) [**PLATE 8**] produced an astonishing 35,000 drawings and prints in his lifetime (an average of two per day), continuing the ancient tradition of woodcut printing, which the Japanese call *Ukiyo-e*, or "pictures of the floating world." Meanwhile, Hokusai's French contemporary Alois Senefelder (1771-1834) invented lithography in 1798 to publicize his plays, creating a process capable of printing 30,000 impressions with one lithographic stone.

By the second half of the Nineteenth Century, Europe had witnessed not only the influx of Japanese woodcuts, but also the transformational

[1] Alpers 2003.

[2] Schwartz 2004.

[3] Schwartz 1991.

[4] Orenstein, nd.

inventions of the industrial revolution: photography, halftones, color-separation, and steam-powered presses capable of printing 10,000 sheets per hour. First came *Daguerreotypomania* [**PLATE 9**], after the French government publicized the existence of this early photographic process in the summer of 1839, then *Japonisme* took over with the reopening of trade with the West in 1854, and finally the poster craze plastered Paris once Jules Chéret (1836-1932) [**PLATE 10**] opened his print shop in 1866, and Europe was flooded with posters by Bonnard [**PLATE 11**], Toulouse-Latrec [**PLATE 12**], and many others (a trend that continues today with the ubiquitous poster reproductions of Degas [**PLATE 13**] and other artists of the time).

PLATES

8. **Katsushika Hokusai.** Kohada Koheiji. ca. 1830.
From Hyaku-Monogatari ("Ghost Tales"). Chúban size woodblock color print. Signature: Zen Hokusai hitsu. Publisher: Tsuru-ya Kiemon. One of the many stories of a man who turned into a snake or serpent after his death. Courtesy of the Tikotin Museum of Japanese in Haifa, Israel. http://www.asianart.com/articles/rubin/4.html

9. **Theodore Maurisset.** Daguerreotypemania. 1839.
Lithograph with applied color, 25.4 x 35.1 cm. Courtesy of the George Eastman House. http://www.geh.org/ne/cromer/m198004610003_ful.html#topofimage

10. **Jules Chéret.** Palais de Glace - Jeune Fille. 1894.
Original lithograph poster in colours. Signed and dated in the stone. Issued as small-scale domestic poster in the form of a supplement to a special issue of the Courrier Français, January, 1895. Printed at the studio of Chaix – the Atelier Cheret. Courtesy of William Weston Gallery. http://www.williamweston.co.uk/pages/catalogues/single/171/28/1.html

11. **Pierre Bonnard.** Poster for La Revue Blanche. 1894.
Color lithograph, 58.7 x 78.2 (23 1/8 x 30 3/4). Courtesy of National Gallery of Art, Washington, DC. http://www.nga.gov/feature/nouveau/teach/slide_03fs.htm

12. **Henri de Toulouse-Lautrec.** Divan Japonais. 1893.
Lithograph poster, 31 5/8 x 23 7/8" (80.3 x 60.7 cm). Publisher: Édouard Fournier, Paris. Courtesy of the Museum of Modern Art Abby Aldrich Rockefeller Fund. Édouard Fournier, owner of the Divan Japonais cabaret in Montmartre, Paris, commissioned this poster after redecorating the nightclub with Japanese motifs. Toulouse-Lautrec depicts two friends in the foreground, cancan dancer Jane Avril and art critic Édouard Dujardin, with singer Yvette Guilbert performing in her signature black gloves in the background. http://www.moma.org/collection/depts/prints_books/blowups/prints_books_001.html

13. **Edgar Degas**. l'Etoile ou Danseuse sur scène. 1876-1877. Pastel, 0.058 x 0.042 cm. Courtesy of Musée d'Orsay, Paris. http://digilander.libero.it/webpainter2/degas/Star.jpg

Reproduction: Limiting the Print Frenzy

By the end of Nineteenth Century, detractors decried the loss of exclusivity caused by the technological introductions of large print runs and photography. For the previous five hundred years in the West, collectors had been happy to snap up as many artist prints as could be produced, and artists happily adopted every new printing technology that enabled them to reach wider audiences for their work. That all changed with the introduction of limited editions, hand signed copies, and what artist Jean-Francois Millet (1814-1875) called the "brutal and barbarous matter" of cancelling plates [**PLATE 14**].[1]

Elizabeth Wyckoff, the New York Public Library's print specialist, credits French critic Phillippe Burty (1830-1890) with first conceiving and promoting the concept of "limited edition."[2] Burty is most famous for coining the term *Japonisme* in the 1870s, and for his early support of Impressionism. He was a founding member of the *Société des Aquafortistes* (Etcher's Society), which was set up in 1862 primarily to prevent photography from being accepted as art. Many influential artists joined the *Aquafortistes* and signed petitions against photography, including neoclassicist Jean-Auguste-Dominique Ingres (1780-1867) [**PLATE 15**] and others.[3]

Print clubs that specialized in limited editions of high-quality fine-art prints began to appear throughout Europe and America, based on the

[1] Wyckoff 2000, p. 17.

[2] Ibid.

[3] Holbert 2004.

model of the *Société des Aquafortistes*.[4] In the second half of the Twentieth Century, this European tradition led to the establishment of experimental print workshops such as Tatyana Grosman's Universal Limited Art Editions in 1957 (Bay Shore, Long Island), June Wayne's Tamarind Lithography Workshop in 1960 (first in Los Angeles then Albuquerque), Ken Tyler's Gemini Graphics Editions Limited (Los Angeles then Tyler Graphics in Mount Kisco, NY and finally the Singapore Tyler Print Institute) **[PLATE 16]**. These master workshops were responsible for training a generation of fine art printers, spawning dozens of print shops throughout North America, developing incredibly innovative printmaking techniques, and publishing original and limited edition prints by the most famous names in Postwar American art.[5]

Yet the broader trends of Twentieth-Century cultural reproduction defied such refined limitation, and had immeasurably greater impact on the art world and the world at large.

PLATES

14. **James McNeill Whistler.** Agnes. 1873/1878.
Etching, catalogue number: Kennedy 134, 225 x 150 mm (8 7/8" x 5 15/16"). This impression is taken from the cancelled plate & printed on laid paper with a high-crown watermark. Repaired one-inch tear in lower-left margin outside plate mark. Image size: 224x151mm. Courtesy of Spaightwood Galleries.
http://spaightwoodgalleries.com/Media/Whistler/Whistler_Agnes.jpg

15. **Jean-Auguste-Dominique Ingres.** Odalisque. 1825.
Lithograph, 131 x 210 mm (5 3/16 x 8 1/4") plus margins. Delteil 9, only state. Published by Delpech in Album lithographique, 1826. Courtesy of R. E. Lewis & Daughter Gallery.
http://www.relewis.com/ingres22big.html

16. **Sidney B. Felsen.** Daniel Buren at Gemini workshop. 1988.
Photograph. © Gemini G.E.L., Los Angeles, California, 2001. Courtesy of National Gallery of Art, Washington D.C. http://www.nga.gov/gemini/88.024fs.htm

[4] Goddard 1998.

[5] Platzker 2000, p. 27.

Reproduction: Its Opposite is Extermination

The true heirs of Nineteenth-Century chromolithography were advertising [**PLATE 17**], propaganda [**PLATE 18**], and mass media. Limiting editions may nibble at the rarified edges of artistic reproduction, but propaganda and advertising destroy the very limits and possibilities of the technologies of reproduction. Any message or image—no matter how bland, bizarre, or brilliant—numbs with sufficient repetition, eliminating diversity, undermining the search for truth, exterminating alternative ideas, with lethal implications for life itself.

The Twentieth Century revealed extremes on both ends of the replication spectrum: expansionary tendencies and hegemonic message-making on the one hand, and authoritarian censorship and control of reproduction on the other. These forces proved capable of influencing and reshaping entire populations, prompting the First World War, the Russian Revolution, Hitler's final solution, nuclear war in Japan, China's one-child policy, and global ecological crises and species extinction. Reaction to the nightmare aspects of capitalism, fascism, and communism, including the manufacturing, media, and military methods behind them, provoked the dominant currents of Twentieth-Century art.

Modernism had a problem: signs of human, scientific, and technological progress were being contested violently throughout the world. Progressive modernists, with their roots in the Enlightenment and the Nineteenth-Century reaction to academic conservatives, were overtaken by a new avant garde that continues to dominate the art world in the Twenty-First Century. The postmodern challenge for visual artists remains: how to respond to the ubiquity of visual culture without

retreating to the philosophical and sensory self-explorations of formalism and art for art's sake? Marshal McLuhan famously said, "advertising is the greatest art form of the Twentieth Century" [**PLATE 19**]. [1] In the Twenty-First Century, can art push reproduction technologies beyond mere commerce and ideology?

PLATES

17. Procter & Gamble Co. I Thought I Was Doomed To Dull, Unattractive Hair Until I Tried Drene. 1937.
Kansas City Star. Courtesy of Duke University Ad*Access Project.
http://scriptorium.lib.duke.edu/dynaweb/adaccess/beauty/hairprep1917-1939/@Generic__BookTextView/96

18. Mikhail Troitskii. Poema o Mashiniste (Poem about the machine operator). 1932. Oformlenie Nikolaia Muratova. Leningrad: Leningradskoe oblasnoe izd-vo. Series: Biblioteka "Leninskikh iskr". 18 page, 19 cm. Agit-prop (a contraction of "agitatsiia" and "propaganda") was used in the Soviet Union after the Revolution to promote appropriate values among the masses, and included books such as Zubarev's Poema o mashiniste. Courtesy of McGill University Rare Books and Special Collections Division. http://digital.library.mcgill.ca/russian/agit.htm.

19. Coco Robot Studios. Che-Britney. ca. 1999-2002.
Street flyer used throughout Boston and New York Universities and city streets to promote the launch of trampt Magazine, designed as a series for the suck:now (subversive urban culture killing) f guerilla marketing campaign. The poster spoofs one of the world's most widely reproduced and merchandized images, the 1960 black-and-white photo of revolutionary Ché Guevara by the Cuban photographer known as "Korda" (Alberto Diaz Guttierez, 1928-2001). Courtesy of © coco robot studios, aka "cocoa robot studios" a division of Abuse The System, Inc., Boston, MA. http://www.cocorobot.com/print-design/flyer-poster/che-britney-spears/

[1] McLuhan, Marshall et al. 1996.

Reproduction: At the Core of Postmodernism

It is not surprising in this context that Marcel Duchamp's 1917 readymade entitled "Fountain" (a urinal signed R. Mutt) [**PLATE 20**] was recently named the most influential work of modern art in the world by a poll of 500 leading artists, curators, critics and dealers.[1] Dadaism, provoked by the mechanized slaughter of the "Great War", with its focus on the random reuse and parody of everyday visual signs, is widely claimed as the herald of conceptualism and postmodernism, two of the most omnipresent aspects of contemporary art at the start of the Twenty-First Century.[2]

Duchamp, a printmaker's grandson, was fascinated by replication, and much of his work challenges the importance of originality. Art historian Francis Naumann calls Duchamp "the first artist in this [*sic*] century consciously and systematically to reproduce his own work."[3]

While the survey undoubtedly has a British slant (it was commissioned by sponsors of the Turner Prize), the prominence of reproduction as a theme in the top-ranked Twentieth-Century work is noteworthy. Picasso's *Les Demoiselles d'Avignon* (1907) [**PLATE 21**], comes in second place, with its appropriation of African masks [**PLATE 22**] and Ingres' *Vénus Anadyomène* [**PLATE 23**], foreshadowing Picasso's invention of collage and his cubist constructions, which in turn inspired Duchamp's

[1] Higgens 2004.

[2] Witcombe 1997.

[3] Naumann 1999.

readymades, and the rich lineage of formal exploration, improvisation, and abstraction that followed.

Andy Warhol's *Marilyn Diptych* (1962) [**PLATE 24**] ranks third, with its fifty silk-screened repetitions of the glamorous actress's face, a work entirely about the relationship of reproduction to immortality, iconography, popularity, simulacra, and death. Also on the list are Joseph Beuys' *I like America and America Likes Me* (1974) [**PLATE 25**], Constantin Brancusi's *Endless Column* (1938) [**PLATE 26**], and Donald Judd's *100 untitled works in mill aluminum* (1982-86) [**PLATE 27**], all of which feature reproduction as a key to their documentation, form, or concept (as political multiples, elegant clones, or minimalist repetition).

In another attempt to rank the significance of art works, University of Chicago economist David Galenson found Robert Smithson's *Spiral Jetty* (1970) [**PLATE 28**] "to be not only the dominant American work of art of the late Twentieth Century, but the most important individual work produced by an American during the past 150 years."[4] His measure: the number of times the work has been reproduced in dozens of art textbooks published since 1990. The original *Spiral Jetty* has barely been seen by the public, not only because of its extreme remoteness in Utah, sixteen miles from the nearest paved road, but also because it has been submerged by the Great Salt Lake for many of the years since it was built. Awareness of Smithson's conceptual work and its significance to the history of art is entirely dependent on technologies of reproduction.

Twentieth-Century artistic strategies are replete with techniques centered on the reuse or reproduction of images: appropriation, assemblage, bricolage, collage, combines, detournement, montage, sampling, readymades. The most widely quoted postmodern philosophers and critical theorists, including Barthes, Baudrillard, Deleuze, Derrida, Jameson, and Lyotard are fixated on reproduction as the central problematic of culture.[5] Many of the top-selling visual artists born after

[4] Galenson 2003.

[5] Barthes 1984; Baudrillard 1994; Deleuze 1994; Derrida 1987; Jameson 1991; Lyotard 1984.

1940 use reproduction as a key element of their artistic strategy, including Jeff Koons [**PLATE 29**], Jean-Michel Basquiat [**PLATE 30**], Felix Gonzalez-Torres [**PLATE 31**], Chuck Close [**PLATE 32**], Damien Hirst, Mark Tansey, and Takashi Murakami (in declining order of their highest auction prices, 2000 to 2003).[6] Reproduction is integral to broader measures of Georg Franck's "attention economy" which values any kind of creative work (scientific or artistic) based upon its ability to garner public and expert recognition.[7] This approach is associated with several other rankings of artistic value that date back to art historian Willi Bongard's influential *Kunstcompass*, which the German magazine *Kapital* began publishing in 1970. After Joseph Beuys became the first European artist to top its list in 1979, he made his now-famous quote: *"Kunst = Kapital"* (Art = Capital).[8]

PLATES

20. **Marcel Duchamp**. Fountain. 1917.
Photo credit: Alfred Stieglitz. Reproduced in The Blind Man, No. 2, 1917, p. 4. Courtesy of Tout-Fait: the Marcel Duchamp Studies Online Journal.
http://www.toutfait.com/issues/issue_3/Multimedia/Shearer/popup_09a.html

21. **Pablo Ruiz Picasso**. Les Demoiselles d'Avignon. 1907.
Oil on canvas, 8' x 7' 8" (243.9 x 233.7 cm). © 2002 Estate of Pablo Picasso/Artists Rights Society (ARS), New York. Courtesy of the Museum of Modern Art Lillie P. Bliss Bequest.
http://www.moma.org/collection/depts/paint_sculpt/blowups/paint_sculpt_006.html

22. **Nkanu Mask**. nd.
Approximately 25" high without raffia. Courtesy of McCue Tribal Arts.
http://www.mccuetribalart.com/masks/nkanu_mask.htm

23. **Jean-Auguste-Dominique Ingres**. Venus Anadyomène. 1848.
Oil on canvas. Courtesy of Musée Condé, Chantilly, France.
http://jllado.free.fr/images/Ingres_Venus_Anadyomene.jpg

24. **Andy Warhol**. Marilyn Diptych. 1962.
Silkscreen, ink/symthetic polymer paint on canvas, 2 panels each 208.3 x 144.8 cm. London: Tate Gallery. Courtesy of © The Andy Warhol Foundation for the Visual Arts, Inc/ARS, NY.

[6] Artprice 2004b, p. XIII.

[7] Franck 1998.

[8] Rohr-Bongard 2004; Artfacts.net 2005.

http://www.tate.org.uk/servlet/ViewWork?cgroupid=999999961&workid=15976&searchid=13980&tabview=image

25. **Joseph Beuys.** I like America and America likes Me. 1974.
Photograph by Caroline Tisdall of Beuys performance at René Block Gallery, New York. Courtesy of the Estate of Joseph Beuys/ARS, NY.
http://www.karlsruhe.de/Kultur/EKT/EKT2000/ekt1.htm

26. **Constantin Brancusi.** Endless Column. 1937-38.
Metal-coated cast-iron modules on a steel spine, height 98 feet, Târgu-Jiu, Romania. Restored and reassembled in 2000, conceived as a monument to young Romanians who died in World War I. http://www.artlex.com/ArtLex/s/images/sculp_branc.endlss.lg.jpg

27. **Donald Judd.** 100 untitled works in mill aluminum. 1982-1986.
Installed in two former artillery sheds at the center of the Chinati Foundation's permanent collection in Marfus, Texas. http://chinati.org/english2/collection/judd_aluminum.htm

28. **Robert Smithson.** Spiral Jetty. 1970.
Mud, precipitated salt crystals, rocks, water coil, 1500' long and 15' wide. Rozel Point, Great Salt Lake, Utah. Photographed by George Steinmetz, September 2002. Courtesy of the DIA Center for the Arts, New York.
http://www.robertsmithson.com/earthworks/Spiral_Jetty_03.htm

29. **Jeff Koons.** Three Ball Total Equilibrium Tank. 1985.
Two Dr J Silver Series, Spalding NBA Tip-Off. Courtesy of the Tate Gallery, London.
http://www.tate.org.uk/servlet/ViewWork?cgroupid=999999961&workid=21383&searchid=4384&tabview=image

30. **Jean Michel Basquiat.** Mona Lisa. nd.
Painting. http://www.postershop.com/Basquiat-Jean-Michel/Basquiat-Jean-Michel-Mona-Lisa-8800167.html%26Partnerid=2922

31. **Felix Gonzalez-Torres.** Untitled (Perfect Lovers). 1987-1990.
Two commercial clocks, 14" x 27" x 1", courtesy of Andrea Rosen Gallery.
http://www.queerculturalcenter.org/Media/FelixGT/3BGclocks.jpg

32. **David Adamson.** Chuck Close Inkjet Self-Portrait Being Prepared. nd.
Photograph. (Assistant John Hughes in picture for final mounting) Courtesy of David Adamson, Adamson Editions. http://www.dpandi.com/adamson/

Reproduction: Identity and Biology

Gertrude Stein's famous line, "rose is a rose is a rose is a rose" makes clear that despite the all-male roster that dominates the art history discussed so far, reproduction has also been a central concern of women artists.[1] To name just a few from the past century: Janine Antoni's compulsive repetitions [**PLATE 33**], Judy Chicago's embroideries [**PLATE 34**], Kathy Grove's *Other Series* [**PLATE 35**], the Guerrilla Girls' advertisements [**PLATE 36**], Hannah Höch's photomontages [**PLATE 37**], Jenny Holzer's message loops [**PLATE 38**], Barbara Kruger's mass communications [**PLATE 39**], Sherry Levine's replications [**PLATE 40**], Bridget Riley's Op Art [**PLATE 41**], Faith Ringgold's quilts [**PLATE 42**], Miriam Schapiro's femmages [**PLATE 43**], Cindy Sherman's recreations [**PLATE 44**], Laurie Simmons' simulations [**PLATE 45**], Lorna Simpson's wigs [**PLATE 46**], and Kara Walker's silhouettes [**PLATE 47**]. The 1997 Guggenheim exhibition "Rrose is a Rrose is a Rrose: Gender Performance in Photography," pushes the connection between reproduction and identity even further, punning on Duchamp's feminine alter ego Rrose Sélavy (which sounds like "*Eros, c'est la vie*" or "Eros, that's life").[2]

When Walter Benjamin states that "even the most perfect reproduction of a work of art is lacking in one element: its presence in time and space, its unique existence at the place where it happens to be," he is describing reproduction as an outcome.[3] Reproduction, however, is not just a mechanical or digital result, but a profoundly biological process. Just as

[1] Stein 1913.

[2] Blessing et al 1997.

[3] Benjamin 1935.

"[t]he uniqueness of a work of art is inseparable from its being imbedded in the fabric of tradition," according to Benjamin, so to are human identities formed only through the social and biological processes of reproduction.[4]

Reproduction becomes dizzyingly complex in the context of identity politics, with its demographic multi-dimensionality. But the lens of identity also simplifies one aspect of the discussion. Sexism, racism, and classism are at the heart of the historical prejudice that places reproduction at the bottom of the Western cultural hierarchy. Western aesthetic hierarchies have long relegated the traditional creative work of women to bottom rung, ranging from the medieval *Bayeux Tapestry* **[PLATE 48]** and other forms of textile design and manufacture to a wide variety of decorative arts.[5] Feminists and people of color from cultures throughout the world certainly do not share this view of the triviality of pattern and decoration.[6] Categorizing, stereotyping, marginalizing, and negating are not only the mechanisms for discriminating taste and differentiating between high and low; they are the basis for the reproduction of social structures, the classic way in which the powerful maintain their position of cultural dominance.[7]

Reproduction in its many forms, as well as its absence, has been central to shaping the history of identity politics. Reproduction spreads fame; omission silences pluralism. Reproduction means sex, birth, death, and evolution. Reproduction is rooted in the body and self image. Sexism and racism are all about reproduction and control, difference and illusion, lineage and heritage, integration and segregation, hierarchy and oppression. The myth of black lasciviousness is a typical racist stereotype to demean and restrain. The idea of "woman's work" centered on the home and reproductive duties is a typical sexist ploy. Both use reproduction as a hierarchical weapon of domination. Striking back are

[4] Ibid.

[5] Gouma-Peterson and Matthews 1987, p. 332.

[6] Art Museum of Missoula 2004; hooks 1995, p. 196.

[7] Bourdieu 1984.

artists who are feminist, people of color, and queer (or LGBT: lesbian, gay, bisexual and transgender), exploring reproduction and their diverse relations to it as biology, technology, and sexuality in ways that disrupt dominant cultural understandings.[8]

No wonder that the culture war's prime targets all happen to be artists who are people of color, queer, and/or feminist, including: Karen Finley [**PLATE 49**], Robert Mapplethorpe [**PLATE 50**], Chris Ofili [**PLATE 51**], Andres Serrano [**PLATE 52**], and an entire generation of hip hop artists whose experiments with sampling challenge the fundamentals of intellectual property law. There is an ancient tangled history of sexism, racism, and hierarchies of reproduction. Centuries before licensing first became law in England (focusing on mechanically reproduced print), the Catholic Church used ecclesiastical licenses to regulate the power of midwives vis-à-vis biological reproduction [**PLATE 53**]. These skilled women were so intimately involved with the sexual, moral, and mortal implications of reproduction that the Church felt compelled to use witchcraft as the ultimate means of accusatory control.[9] With the founding of universities in the Thirteenth Century, all-male medical faculties essentially outlawed female doctors. The Holy Roman Emperor Frederick II (1194-1250) enacted Europe's first medical licensure, requiring candidates to "swear to never consult with a Jew or with illiterate women."[10] From the Fourteenth to the Sixteenth Centuries, thousands of European women were burned at the stake for the "crime" of attempting to heal others.[11]

The historical linkages between racism, sexism, elitism, licensing, reproduction, and exclusion are as culturally deep as any factor influencing contemporary art today. The rub is that artwork which has remained furthest from public view for all manner of prejudice stands to benefit the most from the greatest reproduction and explanation. That is

[8] Corber and Valocchi 2003; Axsom 2002.

[9] Brown 2003.

[10] Group and Roberts 2001, p 24.

[11] University of Iowa 2002.

precisely what is needed to bridge the gap between message sent and message received, between hostility towards difference and openness towards familiarity. Remnants of tribal instincts compound the forces of separation. Artistic expression is a profoundly personal experience that strangely provokes intense psychological resistance to explanation and promotion. For most artists, it is far more difficult to write a simple, compelling artist statement than to produce their best masterpiece. No matter how technologically and culturally sophisticated our society becomes, we must struggle with base motivations. Is not that reality at least partly why a sacred image submerged in blood and urine provokes such strong reaction?[12]

We are living not only in an age of intellectual property and digital reproduction, but also an age of biology. Reproductive rights and copyrights are two of the most profoundly complex and intertwined areas of political contest in the world today, touching all aspects of our society and psyches, from the deepest held religious beliefs to the food we eat. Man-made things—seen onscreen or within urban settings—have replaced nature's prior visual dominance, enveloping our eyes within legal constraints. Artist, curator, and scholar Michael D. Harris points out that "images imposed from power are more difficult to subvert than language…. [I]mages are produced by the few to be consumed but seldom manipulated by the masses."[13] Our most advanced technologies of reproduction are disseminating images and advancing science to such an extent that they not only shape our individual identities but the very future of species, from genetically altered crops to the most advanced interventions of human embryology. Artists such as Brandon Ballengée [**PLATE 54**], Bureau of Inverse Technology co-founder Natalie Jeremijenko [**PLATE 55**], and Eduardo Kac [**PLATE 56**] explore the complex implications of these bio-tech developments.

Clone is just another word for reproduction, but what shivers it sends. Human aversion to technological reproduction is most biological, but

[12] Hudgins 1987.

[13] Harris 2003.

there are complex cultural components to such attitudes as well. Internet pornography may be the ultimate technological reproduction of reproduction (process without product; product without process), and its meteoric market growth reveals an insatiable human appetite that is as biological as cultural. *Artnet Magazine* editor Walter Robinson calls "institutional critique" artist Andrea Fraser's "Untitled" video of having sex with her collector for $20,000 both "the most radical artistic gesture" of 2004 and "the most trivial" [**PLATE 57**].[14] In all of our roles as human beings—consumers, producers, thinkers, citizens, procreators, artists, etc.—each of us contributes to the evolution of these profound social, technological, and biological processes of reproduction.

PLATES

33. **Janine Antoni**. Gnaw (detail). 1992.
600 lb. cube of chocolate gnawed by the artist, 24 x 24 x 24 inches. Collection of the Museum of Modern Art. Photo: Brian Forrest. Courtesy the Artist and Luhring Augustine, New York. http://www.pbs.org/art21/artists/antoni/art_sculpture.html#

34. **Judy Chicago**. A Chicken in Every Pot. 1998.
Painting, needlepoint, appliqué and embroidery, 24 x 18". Collection of the artist and needleworkers. Courtesy of the Judy Chicago and Through the Flower. http://www.judychicago.com/judychicago.php?p=resolutions1

35. **Kathy Grove**. The Other Series: After Lange. 1989-1990.
Silver gelatin print, 71x 66 cm. This photograph digitally morphs Dorothea Lange's classic image "Migrant Mother, Nipopmo, California" (1936) into a smooth-faced model with dirt-free kids, air-brushing real-world problems into Madison-Avenue oblivion. Courtesy of Kathy Grove. http://academic.hws.edu/art/exhibitions/laughter/l2h.html

36. **Guerrilla Girls**. Women in America Earn Only 2/3 of What Men Earn. Women Artists Earn Only 1/3. 1985.
Poster. Copyright © 1985, 1995 by Guerrilla Girls, Inc.
http://www.guerrillagirls.com/posters/twothirds2.shtml

37. **Hannah Hoch**. Made for a Party. 1936.
Photomontage. Institut Fur Auslandsbeziehungen Collection, Stuttgart.
http://www.rmit.edu.au/departments/gallery/2002/Images/Image2.jpg

38. **Jenny Holzer**. Xenon Projection. 2000.

[14] Robinson 2004.

Fundación PROA, Buenos Aires. http://www.proa.org/exhibicion/holzer/salas/holzer-11.jpg

39. **Barbara Kruger.** Untitled (I shop therefore I am). 1987.
Photographic silkscreen on vinyl, 112 x 113 in. (284.5 x 287 cm). Private collection.
http://www.ismennt.is/vefir/ari/myndlist/kruger_ishop.gif

40. **Sherrie Levine.** Fountain (after Marcel Duchamp: A.P.). 1991.
Bronze sculpture. Courtesy of Walker Art Center, Minneapolis, MN.
http://www.askart.com/photos/cny11211996/277.jpg

41. **Bridget Riley.** Breathe. 1966.
Emulsion on Canvas, 117x82 in. http://www.mishabittleston.com/artists/bridget_riley/

42. **Faith Ringgold.** Flag Story Quilt. 1985.
Acrylic on canvas, dyed, painted and pieced fabric, 57 x 78". Spencer Museum of Art, Lawrence, Kansas. http://www.faithringgold.com/ringgold/d37.htm

43. **Miriam Schapiro.** Mother Russia (fan). 1994.
Acrylic and mixed media on canvas (femmage), 82 x 90 inches. Courtesy of Steinbaum Krauss Gallery. http://www.artlex.com/ArtLex/F.html

44. **Cindy Sherman.** Untitled #205. 1989.
Color photograph, 53 1/2 x 40 1/2 inches. Courtesy of the The Broad Art Foundation, Santa Monica, CA. http://www.broadartfoundation.org/collection/sherman.html

45. **Laurie Simmons.** Untitled. 2002.
Photograph, 5.5 x w: 8.5 in / h: 14 x w: 21.6 cm, edition: 25. Courtesy of Carolina Nitsch Contemporary Art, New York.
http://www.artnet.com/artwork/138282/_Laurie_Simmons_Untitled.html

46. **Lorna Simpson.** Wigs (Portfolio). 1994.
Portfolio of 21 lithographs, sheet (each): 23 x 18" (58.5 x 45.8 cm) or 32 x 16" (81.3 x 40.7 cm). Publisher: Rhona Hoffman Gallery, Chicago. Edition: 15. According to MoMA: "Depicted here is a diverse group of wigs in an orderly presentation that suggests a lineup of scientific specimens. Simpson has used the traditional format of the print portfolio in which a sequence of images produces a cumulative, narrative effect." Courtesy of Museum of Modern Art.
http://www.moma.org/collection/depts/prints_books/images/large/745_1995_1_38_simpson.jpg

47. **Kara Walker.** Jockey. 1995.
Cut paper mounted on canvas, 10 x 10 inches. Courtesy of Brent Sikkema, New York.
http://www.nyss.org/cutout/walker.html

48. **The Bayeux Tapestry.** 1073-1083.
Embroidery in wool on canvas or linen, 70 m by 49.5 cm (231 ft by 19.5 in). One of the largest pieces of needlework ever undertaken, it depicts the Norman conquest and events leading up to it. Courtesy of Microsoft Encarta.
http://au.encarta.msn.com/media_121618366_761553879_-1_1/Scene_from_the_Bayeux_Tapestry.html

49. **Karen Finley.** 1-900-ALL-KAREN. 1998.
Aldrich Museum of Contemporary Art (Ridgefield, CT), Allen Memorial Art Museum (Oberlin, OH), Arizona State University Art Museum. (Tempe, AZ), Contemporary Arts Forum (Santa Barbara, CA), CSPS (Cedar Rapids, IA), Diverseworks (Houston, TX), Center for the Arts at Yerba Buena Gardens (San Francisco, CA), MOCA (Los Angeles, CA), Museum of Contemporary Art, San Diego (San Diego, CA), Nexus Contemporary Art Center (Atlanta, GA), Out North Contemporary Art House (Anchorage, AK) and Wagon Train (Lincoln, NE).Commissioned and Organized by Creative Time, New York.
http://asuartmuseum.asu.edu/finley/

50. **Robert Mapplethorpe.** Self Portrait. 1985.
Photograph. Copyright © The Robert Mapplethorpe Foundation.
http://www.mapplethorpe.org/selfportraits7.html

51. **Chris Ofili.** The Holy Virgin Mary. 1996.
Painting. Courtesy of The Saatchi Gallery, London.
http://www.guardian.co.uk/arts/gallery/image/0,8543,-11504640117,00.html

52. **Andres Serrano.** Piss Christ. 1989.
Photograph.
http://www.usc.edu/schools/annenberg/asc/projects/comm544/library/images/502bg.jpg

53. **Medieval Etching (not Trotula). nd.**
"The belief that women were capable of doing physicians' work is represented in this mid-15th century image of Medicine as a Woman. This allegorical image depicts a woman holding up a flask of urine, often shown as the trademark of the physician in medical images during this period." Paula Findlen, Ubaldo Pierotti Professor of Italian History, Stanford University. "Images of the Female Body: The Middle Ages and the Renaissance," 2001. http://www.stanford.edu/class/history13/femalebody.html

54. **Brandon Ballengée.** Cleared and Stained Multi-limbed Pacific Tree frog. 2002.
Aptos, California. Ballengée's work provide disturbing images of deformities occurring in North American amphibians. The clearing and staining procedure involves a series of chemical treatments in which a specimen's tissue is "cleared" using a special enzyme. The cartilage and bone are then dyed red and blue resulting in a specimen that resembles a three dimensional x-ray. Digital imaging courtesy The Institute for Electronic Arts, School of Art and Design NYSCC at Alfred University, Alfred, New York. Courtesy of the Green Museum. http://greenmuseum.org/c/vban/index.php

55. **Natalie Jeremijenko**. OneTrees Project. November 1998 - March 1999.
According to the artist: "OneTrees is actually one thousand tree(s), clones, micro-propagated in culture. The clones were exhibited together as plantlets at Yerba Buena Center for the Arts, San Francisco. This was the only time they were seen together. In the spring of 2003 the clones will be planted in public sites throughout the San Francisco Bay Area."
http://www.viewingspace.com/genetics_culture/pages_genetics_culture/gc_w09/jeremijenko lo res_300.jpg

56. **Eduardo Kac**. Alba (fluorescent bunny). 2000.
Photo: Chrystelle Fontaine. According to the artist: "My transgenic artwork "GFP Bunny" comprises the creation of a green fluorescent rabbit, the public dialogue generated by the project, and the social integration of the rabbit. GFP stands for green fluorescent protein. "GFP Bunny" was realized in 2000 and first presented publicly in Avignon, France."
http://www.viewingspace.com/genetics_culture/images_genetics_culture/gc_wk_03/hoyt/albagreen.jpeg

57. **Andrea Fraser**. Untitled. 2003.
Still from video. Courtesy of Friedrich Petzel Gallery.
http://artnet.com/Magazine/reviews/walrobinson/robinson12-30-10.asp

Reproduction: Celebrity and Survival

Postmodernist critics such as Benjamin and Baudrillard lament the loss of originality, authenticity, and ultimately the primacy of reality as we have moved well beyond the print matrix to the film *Matrix* [**PLATE 58**], including the development of all of the mass-media technologies along the way: motion pictures, recording, radio, television, and most recently the computer.[1] Yet the inevitability of this "withering of aura" or "precession of simulacra" from advances in reproduction technologies seems greatly exaggerated. There are always unanticipated opportunities for resistance, critique, and change, no matter how intellectually compelling such philosophical arguments may be (even if they do inspire a major motion picture). Physical reality and the contradictions of daily life will continue to intrude upon our perceptions for at least the foreseeable future, despite the popularity of reality TV and video games. Especially in the tradition-bound marketplace for fine art, the tenacious value of originality retains its grip. The diversity of reality is incorrigible: a plethora of cultural choices remain even if finding alternatives has become difficult work.

That said, artist resistance to the evolution of mass media has generally proven futile. As actor Ben Gazzara recounts: "When I was in the theater, there was a snobbery about doing motion pictures. Motion pictures were beneath us. Then when I got into motion pictures, television was beneath us. And it's on and on and on. Now it doesn't matter any more."[2] Commercial success and the common self-interests of artists and their

[1] Wachowski and Wachowski 1999.

[2] Gazzara 2004.

producers motivated these developments. The evolution of United Artists Corporation is a case in point. Four motion-picture celebrities (Charlie Chaplin, Mary Pickford, Douglas Fairbanks, and D.W. Griffith) co-founded UA in 1919 as a distribution company to challenge the power that major studios had over independent artists [**PLATE 59**]. By the 1950s, however, UA had grown into just another major Hollywood studio, and was gobbled up by Transamerica in 1967 then MGM in 1981, which in turn was purchased by a Sony-led consortium in 2005. Multinational media mega-mergers are daunting indeed, centralizing control of so much of what is seen and heard throughout the world, and further concentrating artist labor market disparities.[3]

The game of cultural reproduction produces clear winners, while generally hiding its losers. This evolutionary process provides a highly distorted view of the arts economy, even if a totally simulated hyper-real existence remains a philosophical and sci-fi fantasy. Arts and entertainment presents a classic winner-take-all economy.[4] Reproduction plays a central role in this game of survival. It broadcasts the success of winners, creating celebrities who model how artists live, what they do, and who they are. Such omnipresent imagery not only dramatically affects public perceptions of arts, entertainment, and artists, but even the perceptions of professional artists themselves who play the game from the inside. Media reproduced survival bias manipulates the psyches and ambitions of everyone who pursues an art career. The fact that such economics fail to provide a livelihood for nearly all working artists does nothing to stop the ever expanding enrollment in fine art departments, which already award 20,000 undergraduate and 3,000 graduate degrees in visual arts each year.[5] On the contrary, the charismatic myth of the "starving artist" inspires ever increasing levels of artistic production.[6] These motivations are so ingrained in Western Culture that only the *King James Bible* [**PLATE 60**] provides adequate description: "for many are

[3] Bagdikian 2000; Richardson and Figueroa 2004.

[4] Frank and Cook 1995.

[5] Derived from National Center for Education Statistics 2001, table 258.

[6] Røyseng, Mangset, and Borgen 2004.

called, but few are chosen," with deep implications for individual morality, work ethic, sacrifice, and spiritual reward.[7]

The market responds in specific ways to this surplus of artistic productivity. Celebrity culture combined with an appreciation model of aesthetic value focuses art-world transactions on the extremes of "neophilia" and necrophilia. Charles Saatchi is credited with coining the former to describe his habit of searching out new talent in art schools.[8] The recent dominance of conceptual art dovetails precisely with the phenomenon of the hot "emerging" artist and the explosion of the "new". The demand for novelty is usually met by artists early in their careers, often without subsequent significant innovation. This has led observers to claim contemporary art is flooded with masterpieces but few masters.[9] It has also fueled the fastest price rise at auction for works by contemporary artists compared with all other art in recent years, and focused collecting on speculation early in artist careers, since this increases the likelihood of catching the largest winnings.[10] A range of new financial derivatives and even a pension fund have been based on these odds.[11] The biggest payoff in such a model comes with an early demise of the artist, not only because the "death effect" limits supply, but even more so because the publicity surrounding such tragedy heightens the "nostalgia effect" and hence prices.[12] In the long run, the market pays more dearly for the work of dead artists than it rewards those still alive and "emerging". Which brings us back to reproduction: it is all about birth, death, and survival of the "fittest" in the canons of art history.

PLATES

58. **Larry Wachowski** and **Andy Wachowski**. Matrix Revolutions. 2003. Movie poster. Courtesy of Warner Brothers Entertainment Inc.

[7] Matthew 22:14.

[8] Spiegler, February 2004.

[9] Galenson 2003, p. 20.

[10] Artprice.com 2004b, pp. VI-VII.

[11] Porter 2004; White 2004.

[12] Matheson and Baade 2003.

http://whatisthematrix.warnerbros.com/rv_img/rv_poster_smiths.jpg

59. **Charlie Chaplin**. Modern Times. 1936.
Film Still. Courtesy of United Artists.
http://www.doctormacro.com/Images/Chaplin,%20Charlie/Chaplin,%20Charlie%20(Modern%20Times)_01.jpg

60. **King James Bible**. Genealogy 1. 1611.
R. Barker, London. The standard English version for 350 years, incorporating translations by Tyndale, Matthew, and Coverdale as well as other sources. This is a page from the "She" (corrected) issue in which Ruth 3:15 reads: "and she went into the city." Courtesy of The Regents of the University of Michigan, Papyrus Collection.
http://www.lib.umich.edu/pap/exhibits/papyri_james/5_6_7.html

Reproduction: The Myth of Overexposure

If early celebrity is key to artist financial survival, and reproduction is key to celebrity, why would reproduction continue to have such negative connotations in the contemporary world of fine art? It partly boils down to conventional economics: the law of supply and demand dictates greater quantities yield lower prices, and, in the end lower quality and reputation, the ultimate art-world taboo.[1] There are also psychological layers of fear involved: loss of aura, originality, authenticity, and identity, selling out, and catering to consumer preferences. Many artists cannot abide the notion of their work as a reproducible commodity, equating "going commercial" with sin. French sociologist Pierre Bourdieu links this notion to a kind of magical pre-capitalist accumulation of symbolic capital.[2] Artists motivated by non-pecuniary benefits are more likely to pursue avant-garde work that is detached from market demand, causing a secular rupture between high and low culture.[3] The less reproducible is a work of art, the greater the incentive to find the highest bidder. The inverse of this tendency dominates the market for fine art. The entire industry is organized around capturing the most elite collectors, which requires an illusion of scarcity in the midst of overabundance. In this case, Baudrillard was right: myth creates reality, price creates demand. But bubbles can always burst if the right pin is applied.

The visual arts stand out as the most peculiar sector of the arts and entertainment industry when considering reproduction as key to celebrity

[1] Heilbrun and Gray 2001, p. 176; Mutch nd.

[2] Bourdieu 1980.

[3] Cowen and Tabarrok 2000.

and survival. There is an historical "path dependence" to the visual arts' exceptionalism, evoking the quirky tale of how the keyboard came by its inefficient QWERTY configuration in order to prevent typewriter keys from jamming [**PLATE 61**].[4] The cultural evolution of the visual arts industry in America is far more complex than that of the keyboard, and assessing impacts on artists requires more than a words-per-minute measure. Its most distinguishing characteristic relative to the other arts can be summed up in a word: "underexposure", that is, the lack of reproduction, publicity, and celebrity compared with other arts sectors and with visual arts in other countries.

There are many more visual artists working in the United States than any other kind of artist (including musicians, actors, directors, authors, dancers, etc.), yet the organizational infrastructure and market for visual arts is miniscule compared with the other arts.[5] The "art world establishment," as generally perceived, is dominated by museums, dealers, and auction houses, the largest of which are non-profit organizations (such as the Metropolitan Museum), privately-held corporations (such as Christies International Plc.), and family-run businesses (think of any Chelsea gallery). The visual arts in their entirety contribute just four percent of the revenues generated by the arts and entertainment industry.[6] Revenues from the three largest visual arts organizations (Sotheby's, the Metropolitan Museum, and MoMA) are less than one percent of the revenues from the three largest media corporations dominating film, publishing, and music (Time Warner, Viacom, and Disney).[7]

Most visual art depreciates in value, just like automobiles and almost every other commodity in the economy, but the entire fine art market is

[4] Krugman 1995; Leibowitz and Margolis 1995.

[5] Bureau of Labor Statistics 2004; Nichols 2004.

[6] Goldman 2005.

[7] Combined 2001 revenues of $744 million for the top three visual arts organizations (Sotheby's $336M, Metropolitan Museum $240M, MoMA $168M) vs. $75 billion for the primary media segments of the top three media arts organizations (Time Warner $40B, Viacom $19B, Disney $16B). Albarran and Mierzejewska 2004; Philanthropic Research, Inc. 2004; Steiner 2002.

geared to the fraction of a percent expected to appreciate.[8] That means that most art produced by living artists has no transaction value whatsoever. For original works such as paintings, the higher the price the more likely it will appreciate in value over time, with works in the top 1.5% of auction prices, that is individual pieces worth well over $100,000, appreciating by the highest percentages [**PLATE 62**].[9] Only a few dozen living American artists can claim such resale values. Yet there are nearly a half-million professional visual artists in America and more than five million Americans who display their art in public.[10] The promise of appreciation, and hence the benefit of the entire fine art market as it is currently constituted is a fantasy for all but a fraction of a percent of practicing visual artists.

There is a substantial literature on the poor labor conditions of artists: higher unemployment, lower earnings, lower returns per educational investment, fewer transferable skills, greatest earnings inequality, and highest rates of moonlighting.[11] Such conditions are starkest for visual artists, with its most extreme imbalance of labor supply and market demand. Average sales of art for 96 percent of the working visual artists total less than $600 per year. Add to that an average of $100 per artist in total direct grant funds from all federal, state, local, and private sources.[12] Only three percent of working artists, or roughly 20,000 people, succeeds in selling an average of $20,000 worth of work a year. Only 3,000 artists, roughly six-tenths of a percent of all working artists, are represented by New York City galleries. These privileged artists take in an average of approximately $75,000 per year from sales. Only 400 independent visual artists are successful enough to be able to hire more than one employee each. These celebrity artists make more than a half-million dollars per year in sales. The top independent U.S. artist alone commands at least four percent of all the money visual artists make in the United States. Art

[8] Heilbrun and Gray 2001, p. 181.

[9] Artprice.com 2002.

[10] Bureau of Labor Statistics 2001; National Endowment for the Arts 2004; Nichols 2004; Goldman 2005.

[11] Alper and Wassall 2004.

[12] Galligan and Cherbo 2004.

market sales are roughly four times more concentrated than what occurs in U.S. retail as a whole.[13]

Economic concentration is the hallmark of arts and entertainment, but stardom in the rest of the arts generates sufficient revenues to float massive corporations and hundreds of thousands of supporting cast and crew members.[14] This is accomplished by popular consumption of mass reproductions of artistic work.[15] In the visual arts market, in contrast, priority is given to exclusive ownership of original works by a handful of art stars. While favorable critical reviews boost attention in all of the arts, there is a complete disconnect in the primary measure of acclaim between the visual arts and the rest of the arts. For the latter, the number of units that sell defines success (books, CDs, DVDs, videos, tickets, etc.). All that matters in the visual arts, on the other hand, is who buys the work. The closest the visual arts gets to mass reproduction and publicity is advertisements for blockbuster museum shows (mostly for dead artists) and international art fairs (mostly for the aforementioned elite collectors), as well as the assortment of glossy fine art magazines.

ARTnews boasts being "the largest circulation of any fine-art magazine in the world" [**PLATE 63**]. Its 83,000+ subscribers have an average income of more than $200,000, have been collecting art for an average of 17 years, and have accumulated collections worth an average of $183,000.[16] Far from being anything remotely resembling a mass audience, this is precisely the ultra-elite universe of international collectors. Compare this to *Rolling Stone*, the largest circulation magazine in the music industry, with nearly 1.3 million subscribers—fifteen times the *ARTnews* readership [**PLATE 64**].[17] Total earnings of everyone who lives in nearly half of households with the mostly young-adult *Rolling Stone* readers are less

[13] Goldman 2005.

[14] Rosen 1981.

[15] Adler 2005.

[16] ARTnews 2005.

[17] Adage.com 2005.

than $50,000.[18] Is contemporary visual art inherently only of interest to rich people? Is contemporary music inherently an order of magnitude more popular? Or have these contemporaneous disciplines of art production merely evolved within different self-imposed cultural constraints, steeped in contrary attitudes about the value of various kinds of audience exposure and acclaim? Condé Nast's announcement in 2004 that it was planning to unveil an art magazine for the masses suggests that at least certain leading publishers and editors think the 60-million Americans who visit art exhibitions each year (more than attend professional sporting events) hint at a far larger greater potential market.[19] Unfortunately, the 2005 resignation of the project's spearhead, then editorial director James Truman, leaves the venture in limbo as of this writing.[20]

Living celebrities in all of the other arts are household names; not so for visual artists. Britney Spears may have to worry about overexposure as part of her brand management strategy, but such concerns for visual artists border on absurdity.[21] Obscurity is the real threat. Despite the unshakable myth of the working artist toiling alone, greatness is a rare posthumous discovery. The former is ubiquitous, the latter less likely than a lottery jackpot. *New York Times* culture writer Christopher Reardon points to William Congdon [**PLATE 65**], the last surviving member of the New York School, who died in monastic seclusion on the outskirts of Milan in 1998, as the classic "case study in how to derail a promising artistic career" by favoring solitary artistic integrity over fame.[22] The impact of underexposure also reaches to the very heights of accomplishment and prestige in the visual arts. Christies' 2001 sale of Bruce Nauman's 1967 wax and plaster sculpture *Henry Moore Bound to Fail* [**PLATE 66**] for nearly $10 million makes him the single most expensive living visual artist at the start of the Twenty-First Century. Yet

[18] At least according to RollingStone.com user profiles. RollingStone.com 2005.

[19] Carr 2004; National Endowment for the Arts 2004.

[20] Carr 2005.

[21] Frost 2004; Menkes 2004.

[22] Reardon 1999.

how many Americans have even heard of or could recognize Nauman or his work? The visual arts' institutional focus on originality and its deep-seated antipathy towards the kinds of mass reproduction required for popular exposure are the very elements limiting its market reach and ultimately starving the majority of working artists.

One more symptom of underexposure: only visual artists have no organized labor representation. The rest of the arts have matured as industries and grown in scale to support a multitude powerful unions: Actors Equity, American Dance Guild, American Federation of Television and Radio Artists, American Guild of Musical Artists, American Guild of Variety Artists, American Musicians Federation, National Writers Union, Screen Actors Guild, Writers Guild of America, etc. The closest such organization for visual artists is the Graphic Artists Guild, which is geared towards design and illustration professional rather than the varied fine artists.[23] (Hence its membership base is omitted from the labor statistics presented above.) Ironically, the very origins of labor associations began with artisan guilds dating from Roman to Medieval times. With "gild" at their Anglo-Saxon etymological root, such organizations point directly back to Europe's first engravers and printmakers, who were commonly goldsmiths [**PLATE 67**]. At one extreme, to see the day-to-day value of such organizations for working artists, just compare the manifold protections of a standard "U5" acting contract for speaking under five lines on TV to the utter lack of legal safeguards from a standard consignment form for entrusting a gallery with tens of thousands of dollars worth of visual art inventory. On the other extreme, one need only look to the Fortieth President of the United States [**PLATE 68**] (or the current governor of California) to see what power such organizational development can truly muster. The political and economic power of reproduction has been all but lost on the visual arts with its overwhelming focus on individualism and originality.

PLATES

61. **Mad Editors**. The QWERTY Mad. 1991.

[23] Graphic Artists Guild 2003.

New York, NY: Warner Books Inc.
http://www.collectmad.com/collectibles/qwertymw.htm

62. **Pablo Ruiz Picasso**. Boy with a Pipe. 1905.
Oil on canvas, signed Picasso (lower left), 39 1/4 by 32 in / 99.7 by 81.3 cm. On May 5, 2004, the work was auctioned at Sotheby's - New York for $104,168,000, the highest price ever paid at that point for a single work of art. It was purchased by an anonymous buyer from the Greentree Foundation's Collection of Mr. and Mrs. John Hay Whitney.
http://www.artchive.com/artchive/p/picasso/picasso_boy_with_pipe.jpg

63. **ARTnews**. Cover: Great Underrated Artists. 2005.
Volume 104, Number 1. January. http://artnews.com/images/covers/ACF1FBB.gif

64. **Rolling Stone**. Cover: 500 Greatest Songs of All Time. 2004.
Number 963, December 9.
http://m1.buysub.com/wcsstore/RollingStone/images/R963coverct.jpg

65. **William Congdon**. La Madonna Del Presepio. 1984.
579x864 cm. SS. Pietro e Paolo alla Cascinazza, Milano.
http://www.christusrex.org/www2/art/congdon.htm

66. **Bruce Nauman**. Henry Moore Bound to Fail. 1967.
Plaster with wax, 26 x 24 x ca. 4 in. Sold for $9.9 million at Christie's New York, May 17, 2001. http://www.thecityreview.com/s01ccon1c.gif

67. **Jan van Eyck**. Portrait of Jan De Leeuw. 1436.
Oil on panel, 7.5" x 9.5" / (19.0cm x 24.0cm). De Leeuw was dean of the influential Goldsmith's Guild in Bruges. The origins of printing are intricately entwined with goldsmiths' tools and guilds. Albrecht Dürer would have first encountered the burin (or engraver) in his father's goldsmith shop; even Johann Gutenberg was affiliated with the goldsmith guild of Strassburg. Courtesy of Kunsthistorisches Museum, Vienna.
http://www.artchive.com/artchive/v/van_eyck/eyck_leeuw.jpg

68. **Ronald Reagan**. Testifying before the House Un-American Activities Committee as President of the Screen Actors Guild. 1947.
October 25. Hand-tinted by Bennett Hall © 1999. Courtesy of Ronald Reagan Library and the Business Image Group, San Francisco, CA.
http://businessimagegroup.com/presidentialimages.com/Reagan.html#Anchor-56321

Reproduction: Still Second Class

Two years after Andy Warhol's death in 1987, Graham Nash [**PLATE 69**], of Crosby Stills Nash & Young fame, and David Coons, an Academy Award-winning animation engineer from the Walt Disney Company, produced the first digital IRIS fine art print.[1] Given the historical tensions and developments previously outlined, it is not surprising that the pioneers of digital art printmaking would be a rock star and a California-based film technician rather than a New York visual artist or master printmaker. Nash Editions has spawned a digital reproduction industry that could end the underexposure of visual art. The remarkable print quality that cost Nash $126,000 for an IRIS Graphics 3024 printer in 1989—an amount that only a celebrity could afford—can today be replaced by a wide-format Epson or HP inkjet printer for a few thousand dollars. Despite the potential, the art world is far from universally welcoming the full implications of this new technology, and instead displays the contradictory tendencies of elite resistance and avant-garde experimentation that have long been the twin trademarks of Western art history.

More than a decade after the first IRIS prints, digital printing and reproductions remain near the periphery of the fine art world, infrequently seen at Chelsea galleries, London auctions or even fine art print fairs. Great importance is still given to limiting the edition of digital prints, even though there is no technical reason for doing so, nor even the physical possibility (any digitally printed output can be rescanned and reproduced at virtually the same quality and size). Fourteen states have

[1] Johnson 2005.

fine art print disclosure laws specifying detailed contents of certifications of authenticity, even though many parameters are nonsensical in the context of digital reproduction (such as status of plate or master).[2]

Consensus on nomenclature for digital applications remains elusive even in the most traditional media such as works on paper. Many try to distinguish between (a) "digital prints" of art created originally on a computer, (b) "digital reproductions" of art created with a different media then digitally photographed or scanned, and (c) a "fine art print" that directly involves the hand of an artist and master printmaker in some aspect of the process of reproduction. The problem with such distinctions is that all manner of combinations of these processes are possible, and all kinds of quality can result from any one, in terms of both artistry and materials. Jack Duganne, Nash Editions' first printmaker, coined the term "giclée" in 1991 based on the French verb "to spray" (*gicler*). Many American artists refrain from using the moniker, because of its simultaneously pretentious whiff of European origins and kitschy connotation of highfalutin sales-slick gimmickry hiding what may otherwise be an ordinary poster. Here we begin to stumble into the contraband terrain of inauthentic work, along with fakes and forgeries, among the most disreputable neighbors of reproduction.[3]

The unrivalled master of giclée is universally reviled by art-world aficionados, who call his work "schlock" and "a big turnoff."[4] As the top grossing artist in the world today—and by far—Thomas Kinkade, the self-described "Painter of Light™," can laugh all the way to the bank [**PLATE 70**]. He has reportedly sold more than ten million copies of his paintings (not one original!), earning more than $100 million per year for his corporation over multiple years (before taking it private in 2004), and generating more than $500 million per year in licensed product revenues.[5] His empire includes not only a finely articulated product schedule of

[2] Art Publishers Association, nd.

[3] Elkins 2004.

[4] Davis 2004; Lazarus 2002; Miller 2002.

[5] Brown 2002; License! 2004; Media Arts Group 1997-2003.

signed limited edition prints that mimic art historical hierarchies (including various proofs, certifications, hand highlights, etc.), but all manner of goods from calendars to candles, greeting cards, furniture, wall paper, a novel (*Cape Light*), and even a real estate development ("The Village at Hiddenbrooke"), not to mention thousands of gallery franchises throughout the country, a 300,000-square-foot manufacturing facility in California, and hundreds of employees, including several executives who earn six- and seven-figure salaries and bonuses.

Many may doubt that Kinkade will ever be considered the Rembrandt of our times, or even looked back upon as a contemporary Norman Rockwell. Kinkade is the single most disliked artist by American art critics, according to a recent Columbia University survey.[6] (The critics give similarly poor ranks to LeRoy Neiman, another bestselling artist of reproductions.) Even an acclaimed champion of popular art such as Dave Hickey, who is famous for reviving previously discounted concepts such as beauty and artists such as Rockwell, says of Kinkade, "one of my 'heroes'[,] he isn't."[7] In addition to his 2001 MacArthur "genius" award, Hickey ranks as the fifth most influential writer among U.S. art critics in the same poll, above Walter Benjamin, Meyer Schapiro and Harold Rosenberg.[8]

There is no argument, however, regarding this indisputable historical fact: licensed sales of Kinkade's work are substantially greater than the revenues of any other organization in the visual art world today, including Sotheby's (the largest publicly held auction house), and double the revenues of the Metropolitan Museum of Art, the largest museum in the United States (including all of its sources of revenue: gift shop sales of reproductions and other paraphernalia, admissions, donations, art sales, etc.). It is even more incredible that broadly scanning the vast literature of contemporary American art—from academic books to glossy magazines to art websites—you might never even know he exists.

[6] Szántó et al. 2002, pp. 40 and 44.

[7] Hickey 1993, 1997, and 2000; Dewan 1999.

[8] Szántó et al. 2002, p. 36.

In return for his art-world anonymity, Kinkade, who graduated from the well-regarded Art Center College of Design in Pasadena, not only ignores the intellectual interests of the art-world elite, he unapologetically embraces exactly the kind of work held out for ridicule by the likes of Soviet émigré artists Komar and Melamid and their "America's Most Wanted" polls [**PLATE 71**].[9] So much scorn has been heaped on Kinkade and others who have pursued this populist approach to reproduction, that their enormous enterprise is all but invisible to participants and onlookers of the international art world. Wildlife artist Terry Redlin— who despite selling more than $20 million worth of Americana each year, single-handedly raising $28 million for Ducks Unlimited [**PLATE 72**], and building a $10 million museum for the State of South Dakota, still does not rank among the top ten art licensors—calls these contemporary masters of reproduction "a hidden industry."[10]

What historian Lawrence W. Levine terms the "cultural bifurcation" of America between high and low arts is most extreme in contemporary visual arts.[11] This is not just a matter of the general public's difficulties understanding and accepting the most challenging avant-garde work, which happens in all fields of artistic endeavor. More significantly, the connoisseurship that rules the visual art establishment disregards the largest segment of its own industry, discounting not only the aesthetics of such popular work, but its technological and fiscal underpinnings. The former is a matter of taste, the latter, financial suicide. In a single-minded pursuit of value through the monetary appreciation of celebrity output, the arbiters of contemporary fine art have ignored the very mechanism by which superstars are created: large-scale systems of reproduction. By snubbing individuals who have most successfully pursued the latter strategy, the art world has conspired with the art market to conflate reproduction with poor quality. Upon reflection, however, does not this equation seems so passé, rooted in early Twentieth-Century American

[9] Wypijewski 1997.

[10] Cray 1999.

[11] Levine 1988.

anti-immigrant sensibilities (distinguishing between highbrow and low), and even back to the anti-photography sensibilities of the *Aquafortistes*?[12]

PLATES

69. **Graham Nash**. Self-Portrait at the Plaza Hotel, New York. 1974.
Courtesy of Nash Editions, Manhattan Beach, CA.
http://www.digitaljournalist.org/issue0105/nash01.htm

70. **Thomas Kinkade**. In the Garden of Hope. 2005.
Giclée, sizes: 16x12 / 24x18 / 34x25.5 inches. Artist's statement: "Hope is the great gift of a loving God. For people of faith, hope is symbolized in the dawning of each day, the assurance that God's love is new every morning. Hope lights our spirit in the midst of despair; it is the life force that 'through the green stem drives the flower;' it keeps a divine vision alive in the hearts of the weak and needy." Courtesy of The Thomas Kindade Company, Morgan Hill, CA.
http://www.thomaskinkade.com/magi/servlet/com.asucon.ebiz.catalog.web.tk.CatalogServlet?catalogAction=Product&productId=203201

71. **Vitaly Komar** and **Alex Melamid**. United States: Most Wanted Painting. 1995.
Oil on canvas, dishwasher size. With the support of the Nation Institute, the artists hired Marttila & Kiley, Inc. to survey 1001 adults for America's most and least wanted paintings, which were exhibited as the "People's Choice" in New York at the Alternative Museum. With the sponsorship of the Dia Center and Chase Manhattan Bank, they expanded their market research to other countries, and created most and least wanted paintings for each. Courtesy of the Dia Center, New York. http://www.diacenter.org/km/usa/most.html

72. **Hayden Lambson**. Clear Landing (Ducks Unlimited Catalogue Cover). 2004.
From print, limited edition of 5,500; frame size: 22"H x 30"W. "Chosen to adorn the cover of the Ducks Unlimited catalog, 'Clear Landing'... [is] now exclusively available as framed and matted prints. This is the perfect chance to begin a distinct one-of-a-kind collection. A winter landscape, morning's soft light, mallards cupped and ready to sit - Hayden Lambson's artistic vision is that of a dedicated waterfowler and it's strikingly apparent in this work. With 'Clear Landing' hanging in your home or office, you're only a glance away from momentary freedom." Courtesy of Ducks Unlimited, Kearney, NE.
http://www.ducatalog.com/catalog/default.php

[12] Gans 1999; Kammen 2000; Keller 2004.

Reproduction: The Secret is Out

Key financial fundamentals of the U.S. art market are remarkably little known. Intellectual property is the future of the American economy: imagination made real, creations of the mind, design and invention. This form of property, protected by patents, trademarks and copyrights, is one of our largest and fastest growing economic assets, contributing more than a trillion dollars to the domestic economy, and leading U.S. exports.[1] Arts and entertainment are at the core of this financial powerhouse, generating a third of all domestic and foreign intellectual property sales.[2] Visual art is the fastest growing sector of the international licensing industry, the key legal mechanism for marketing copyrighted materials.[3] Reproduction dominates art sales, yielding two-thirds of the $30-billion domestic art market, and increasing shares relative to original art and all home furnishings.[4] Framed reproductions are the largest and fastest-growing sector of the visual art market, with $16 billion in domestic sales, rising by 15% per year—double the growth of total art sales, and three times the sales growth for original art.[5] Digital fine art printing is expanding the fastest, with the market for reproductions using the latest technology projected to double within three years at a 20% annual sales

[1] Howkins 2001; Florida 2002; Siwek 2004.

[2] U.S. Census Bureau 2001; Chartrand 1992; Siwek 2004, p. 15.

[3] License! 2004 and LIMA 2004.

[4] Unity Marketing 2003, p. 3 and Home Accents Today 2000.

[5] Unity Marketing 2003, p. 3.

growth rate.[6] Digital prints are expected to replace lithography and serigraphy as the primary fine art technology in 2005.[7]

Such compelling bottom-line data are rarely encountered in literatures relating to the visual arts. The information is from remarkably disparate sources, ranging from arcane government tabulations to industry associations for printers and printing equipment, publishers, home furnishings, international licensing, and intellectual property concerns. The fact that these resources are far removed from traditional origins of art world authority—be they art history or conservation, appraisal or criticism, art curating or art making—does little to diminish the compelling economic indications imbedded therein: the future of art lies in reproduction.

Comparisons with more familiar sources are no less revealing. According to Americans for the Arts, the combined budgets of all non-profit arts organizations in the United States total more than $50 billion per year.[8] The National Endowment for the Arts estimates that half of this amount is raised by donations (40% private; 10% public) and half by earned income.[9] Roughly 10% of this total is generated by the non-profit visual arts, including museums, alternative spaces, etc., and the rest by non-profit organizations in all of the other art disciplines (theaters, orchestras, opera companies, art service organizations, etc.).[10] In comparison, the Art Publishers Association puts U.S. sales of wall art reproductions at $20 billion per year.[11] Taken together, these estimates suggest that art reproductions generate as much revenue as all foundation, corporate, and individual donations to all of the non-profit arts. Art reproductions yield four times the $5 billion economy of the entire non-profit visual arts

[6] CAP Ventures 2004 and Chaker 2004.

[7] IT Strategies 2002.

[8] Americans for the Arts 2003.

[9] National Endowment for the Arts, October 2004.

[10] Goldman 2005.

[11] Unity Marketing 2003.

sector, which has dominated the art world since W. McNeil Lowry of the Ford Foundation invented the leveraged arts grant in the 1950s.[12]

While the non-profit world plays a key role in establishing art-world reputations, for-profit fine-art galleries and auction houses set the sale and resale value of original works of art, the core of the fine-art appreciation economy. Aggregate economic comparisons with these profit-oriented pillars of the art world are similarly lopsided. Sales of art reproductions in the U.S. are three times the highest private estimates of U.S. art auction sales ($6B), six times government figures for U.S. art gallery sales ($3B), eight times the entire U.S. market for contemporary art ($2.5B), twenty times the Census figures for U.S. auction sales of fine art ($1.1B), and fifty times the international auction market for contemporary art ($384M).[13] In sum, sales of art reproductions are double the sales of all original art in America according to market research commissioned by the Art Publishers Association.[14]

Alarming trends in traditional arts funding makes the case for reproduction stronger still, even if the art publishers' market estimates overstate the static relative shares. Average U.S. art auction prices have fallen by about 25% since their peak in the year 2000.[15] There are longer-term, secular trends forcing prices down: for nearly two decades prior to the recent market peak, the real value of average sales per art dealer in the U.S. fell by 30%.[16] Federal funding for the arts declined even faster, by 70% since its real-dollar peak 25 years ago.[17] State funding has declined for three straight years, by 24% in the last year alone in real dollars.[18] Federal per-capita spending on the arts is the lowest in the industrialized world, and the press barely reports when much ballyhooed (though

[12] Kreidler 1996.

[13] Kusin 2002; U.S. Census 2001; Goldman 2005, Table 8; Hislop 2005b (respectively by statistic).

[14] Unity Marketing 2003.

[15] Hislop 2005a.

[16] Derived from National Endowment for the Arts 2004 and U.S. Census Bureau 2001.

[17] Derived from National Endowment for the Arts 2003.

[18] National Association of State Art Agencies 2004.

pitiful) increases get axed by Congress.[19] Private charitable funding is declining even faster than government spending, according to museums finances, falling by a third during the late 1990s even as the art market surged (with museum shop sales of reproductions and other art-related products picking up the slack).[20] Foundation grants to the visual arts now make up just one-half of one-percent of all foundation giving.[21] No wonder the Ford Foundation, and dozens of other major arts funders have recently invested in the most intensive study of the failure of the non-profit support structures for U.S. artists.[22] As the most visible component of the visual art industry, the non-profit model holds a major responsibility for creating the overwhelming supply of discounted labor among artists, as well as arts administrators, who are disproportionately female and poorly paid even by non-profit standards.

The trends for art reproduction are the polar opposite, with ubiquitous indications of market growth, from the rapidly falling price of wide-format printers, to the explosion of online art vendors, to a host of surveys showing double-digit increases in the sales of wall art and décor and related equipment and supplies.[23] The vast market opportunity is literally all around us. There are more than two billion walls in American homes, and all need art.[24] Wall space is increasing, with homeownership, home sales, the size of new housing, and remodeling expenditures (especially for bathrooms) all representing rapidly growing sectors of the economy—along with the rapidly expanding square-footage of offices and other commercial real estate.[25] Surveys show American households are as likely to buy wall art as electronics.[26] The only question is: whose creativity will be on the walls and minds of Americans? More specifically:

[19] National Endowment for the Arts 2000; Papatola 2004.

[20] Derived from Heilbrun and Gray 2001, p. 211.

[21] Derived from Grantmakers in the Arts 2001, p. 1, figures 2 and 5.

[22] Jackson et al. 2003.

[23] Sher 2000; Unity Marketing 2001.

[24] U.S. Census Bureau 2000.

[25] Unity Marketing 2001.

[26] Southeastern Institute of Research 2001.

will the work of living visual artists have a place alongside flat panel TVs, mirrors, Van Gogh posters, and family photos? This is a challenge that cannot be met without fully exploiting the latest technologies of reproduction. It is also the central challenge to the livelihoods of working visual artists.

Reproduction: Slow Motion Technicolor

The latest advances in computer technology have so far had remarkably little impact on the visual art market, especially compared to their impacts on rest of the arts and the economy as a whole. The widespread growth in digital reproduction onto paper, canvas, and other substrates may be "one of the highest mark-up specialties in commercial digital printing," but the far more cutting-edge high-tech applications of new media artists have yet to gain much of a commercial or popular foothold.[1] The slow pace of commercial diffusion stands in sharp contrast to the warp speed of innovation that marks the work of new media artists. The new media pioneers are light-years ahead of the museum-going public, as great a gap as there has ever been between an artistic avant garde and popular appreciation.

The 2004-2005 "Scratch Code" exhibition at Bitforms Gallery [**PLATE 73**], which may be New York's only commercial gallery dedicated solely to digital art, traces a five-decade lineage of remarkable but relatively little-known computer-based art.[2] There are now art blogs and art mobs, innumerable internet-art experiments and websites (such as Ars Electronica at www.aec.at, E-flux at www.e-flux.com, Rhizome at www.rhizome.org, or Turbulence at www.turbulence.org), as well as the occasional museum reviews (such as "Bitstreams" at the Whitney Museum and "010101" at SFMoMA in 2001, or "Gallery 9" at the Walker Art Center since 1997), and dedicated alternative spaces (such as New York City's Franklin Furnace and Eyebeam, also on the web at

[1] Webster 2000, p. 211.
[2] Sacks 2004-2005.

www.franklinfurnace.org and www.eyebeam.org).[3] Contemporary art lovers who have not kept up with the high-tech cognoscenti, however, may still be shaking off the long-lasting hangover of 1970s-based paintbrush software, and its countless déclassé creations of digital expressionism, as well as the more recent and painful memories of anything remotely resembling a dot.com.[4] For the moment at least, traditional media and modes of commerce continue to dominate the visual art market.

From the most ephemeral web art to the most massively corporeal computer-generated sculpture, to the highest-end plasma-screen image distribution systems, the infinitely reproducible work of new media artists and art-related digital technologists test traditional art market structures for showing and selling fine art.[5] Dealers engage in a variety of contortions to restrain the inherently limitless replicability of digital art. Galleries are trying limited "electronic editions" of digitally-based art by hot acts such as "Assume Vivid Astro Focus" (Rio-born, New York-based artist Eli Sudbrack) [PLATE 74]. This commercial construct attempts to maintain exclusivity and high prices, even if the certificate of authenticity refers to a CD-ROM-based Adobe Illustrator file capable of reproducing hip wallpaper in unlimited quantities.[6] New media art has many paradigm-shifting potentials—including: simultaneous global access, interactivity, virtuality, artificial-intelligence, animation, morphing, gaming, hypertexting, linking, networking, browsing, etc.—but its most immediate threat to the status quo is infinite reproducibility.

To gauge the comparatively minor impact such new technologies have had to date on the visual arts market, consider the shockwaves that Napster has had on the music industry: billion-dollar losses put a multinational industry into a tailspin. The profound impact of digital technology on the production and distribution of motion pictures is also

[3] Gilbert 2004; Greene 2004; Middlebrooks 2001; Paul 2003; Rinder 2001; Ross 2001; Rubenstein 2005.

[4] Hirshberg 2004.

[5] Ganis 2004; Graham 2004; Walker 2003.

[6] Spiegler, November 23, 2004.

common knowledge, from Pixar to DVDs to avatars replacing actors. Publishing has been similarly transformed, from e-books to amazon.com to Google's plan to scan tens of millions of books for online searching. The universe for full-text reproduction includes literary works that are older than the 70-year U.S. copyright protections, yet more information has been produced in the last 30 years than in all of the five-thousand previous years of human civilization. No wonder these profound technologically induced transformations of the information age are so widely compared with Gutenberg's invention six-hundred years ago. Who, in contrast, has heard of the far-reaching application of "rapid-prototyping" technology to visual art that enables computer-generated physical production of any three-dimensional sculpture, pioneered by new-media sculptors such as Michael Rees [**PLATE 75**]?[7] For that matter, who has heard of—or can even pronounce—"giclée"?

For the visual arts, these technological advances have yet to congeal in an obvious trend, and have led digerati to ask (though with plenty of historically grounded irony): "why have there been no great net artists?"[8] Applications are too premature to herald a new Renaissance, despite hints of something big brewing. Inherent characteristics of visual arts contribute to their slower internalization of these technological forces. At the most basic level, visual arts are more "high touch," as the Japanese say, than the other arts.[9] The instinct that prompts every museum to post "DO NOT TOUCH" runs deep [**PLATE 76**]. Humans have a visceral need to see and feel in-person the hand-made granularity of actual works of visual art. A printed book is in many ways more convenient and satisfying to read than an e-book. A live performance has many more layers of artistic reward than a recording or film. But the essential physicality of visual art cannot be as easily reduced to purely digital output as can words, music, and movement.

[7] Ganis 2004; Tompkins 2004.

[8] Dietz 1999.

[9] Pratt 2001.

There are also numerous technical impediments slowing the potential wider impacts of a visual art and high-technology merger, as well as many historical and cultural biases against such blending. The mostly temporary technological glitches range from the difficulty of downloading large high-resolution files, to the finicky calibrations of high-quality output devices, to the complexity of specifying user-friendly search protocols for image characteristics. Cultural resistance is far more lasting. David Hockney's suggestion that old masters may have used (now primitive) technological means as part of their creative process has caused a such ruckus that cries of blasphemy and sacrilege would seem minor in comparison, with the most sophisticated scientific evidence being marshaled to disprove the very idea [**PLATE 77**].[10] New media artists, in contrast, have left the general public so far behind, that their latest innovations are too obscure and far removed from what is commonly thought of as "art" to generate such publicity or controversy.

These obstacles, however, do little to stop artists and assorted art owners, dealers, and licensees from trying to peddle art online. Ebay lists as many as 600,000 post-1950 paintings annually.[11] Absoluteart.com, which lists nearly 100,000 works of contemporary art at any one time, claims to be "the largest and most visited collection of contemporary art on the internet."[12] This is essentially the online equivalent of a massive art vanity press. The site makes its income from artist membership fees and other advertisements. Despite the similarity of its name to the Absolut Vodka brand [**PLATE 78**], verbally associating the site with the latter's celebrity artist advertising, there appears to be no such official relationship. And despite claiming a jury "review" for their most expensive listing packing, only about 10% of the 10,000 artists represented pay for these services, and there is no indication why any prospective premium paying customer would ever be rejected.

[10] Hockney 2001; Stork 2004; Cornwell 2005.

[11] Bauer 2003.

[12] World Wide Arts Resources 2005.

This massive self-selected body of work provides statistical insight into what emerging artists want to exhibit and sell online. While 90% of art bids and sales on eBay are for less than $100, the more hopeful artists on absoluteart.com list only 14% of their work at such entry-level prices. Original paintings and works on paper make up three-quarters of the listings, followed by new media art, with 6,000 works of computer art, computer animation, and video comprising 6% of the listed art, more than sculpture and all other categories. Giclée reproductions represent less than 3% of the work on the site. Of course, these data say nothing about actual sales.

Compare this with Nextmonet.com, one of the earliest, high-profile, and still-surviving fine art websites. It began by representing international art celebrities, but they all seem to have fled, and it now only sells works by far lesser-known emerging artists. Nextmonet has a "panel of art historians, curators, artists, and educators" that "accepts only a small percentage" of submissions based on a variety of artistic and commercial considerations.[13] This selection process yields only 635 different works by 79 artists currently online. Their company's pricing schedule is remarkably similar to the artist-determined prices on absoluteart.com, with 14% less than $150 and about half less than $500, but their content differs significantly. More than a third of the listed works are giclée reproductions, which Nextmonet also distributes via a glossy snail-mail catalogue. There is no new media art whatsoever listed on the site. Short of actual sales data, these content differences between supply-driven absolutearts.com and demand-driven nextmonet.com suggest the wide gulf between artists' technological ambitions and public interest.

At the very height of the internet bubble, the internet ranked second-to-last as a venue for consumer art sales (including originals and reproductions), despite the proliferation of web image banks and visual

[13] **Nextmonet.com 2005.**

art e-commerce sites.¹⁴ As recently as 2005, even Bill Gates' massive photography archive, the Corbis Corporation, had yet to make a profit.¹⁵

This state of affairs could change at the flip of a market switch, or a particularly strategic infusion of capital. Getty Images, the stock-photo industry leader, with a half-billion-dollar internet-based B2B service, for example, has recently seen its revenues, profits, and stock prices rise in double-digits. Analysts speculate that Corbis will soon be a major IPO candidate.¹⁶ Art.com, the consumer web division that Getty killed in 2001, was bought by two North Carolina entrepreneurs, who have since turned a profit with the site.¹⁷ Eyestorm, which filed for bankruptcy in 2001, having seduced David Ross from his $393,000-a-year San Francisco Museum of Modern Art directorship and blown $26 million in venture capital, became the veritable poster-child of myriad fine art dot.com disasters.¹⁸ The enterprise has subsequently refinanced (far more modestly), merged with Britart.com, and now proclaims itself to be largest website devoted to the sale of modern and contemporary British art, with five bricks-and-mortar gallery franchises in England and New York.¹⁹ Even discount giant Costco is getting into the act, selling fine art prints priced from hundreds to tens of thousands of dollars online.²⁰

Continued growth of online art sales seems inevitable even if slow moving, but that trend does not necessarily translate into greater public appreciation—let alone paying customers—for the latest innovations in new media art.

PLATES

73. **Tony Pritchett**. Flexipede. 1968.

[14] Unity Marketing 2001.

[15] Graybow 2005.

[16] Graybow 2005.

[17] Walker 2004.

[18] Mirapaul 2002.

[19] Netimperative 2003; Enterprise North East 2004.

[20] Forstenzer 2004.

Video/Film/Digital Art, 16mm film transferred to DVD, Duration: 2:00. Included in the Scratch Code exhibition, November 12 2004 - January 16, 2005. Courtesy of Bitforms Gallery, New York. http://bitforms.com/images_ex/scratch7.jpg

74. **Assume Vivid Astro Focus.** Garden IV wallpaper and y.o floor sticker. 2003. Installation View. Courtesy of Oliver Kamm 5BE Gallery, New York. http://www.5begallery.com/content.php?mode=gallery§ion_id=14

75. **Michael Rees.** Putto 4 over 4. 2004.
Luminore iron on fiberglass over Styrofoam with a steel tube armature, 145 x 87 x 138 inches. Courtesy of Michael Rees and Bitforms Gallery, New York. http://michaelrees.com/indexes/hossTheManColorShiftsm.jpg

76. **Do Not Touch.** nd.
Courtesy of Magnum UK Ltd, Tiverton, England. http://www.instant-art.com/catalog-safetysigns/prohibition/pages/proh003-do%20not%20touch.htm

77. **David Hockney.** Chair, Jardin de Luxembourg, Paris. 1985.
Photocollage, 110.5 x 80cm. Courtesy of David Hockney.
http://www.cs.waikato.ac.nz/~cbeardon/dcollage/collage2/images/Hockney/chair.jpg

78. **Eric Adigard.** Absolut Adigard. 1996.
Courtesy of Absolut Vodka.
http://www.absolutcollectors.com/gallery/ad.cgi?b=category&c=Wired%20Magazine&a=adigard

Reproduction: Spawning the Unexpected

Technological change certainly does not provide a materialist guarantee of economic or political transformation; on the contrary, advances in information systems often reinforce existing power relations and exacerbate inequalities.[1] Nevertheless, technological innovation can offer significant and surprising opportunities, depending on who masters the new tools and to what ends they are applied.

Digital technology can have widely inequitable benefits and harms for various interests in the production and consumption of arts. The recording, publishing, and movie industries have gone to great lengths to crack down on file sharing and other forms of unauthorized copying—from securing legislative protections to suing college students. The Pew Internet and American Life Project, on the other hand, finds most paid and unpaid artists and musicians think such peer-to-peer distribution "has had a positive effect on their creative lives and careers."[2] The dual paramount economic concerns of efficiency and equity are the basis for these conflicting positions. The bottom-line question is: how to maximize profit without limiting distribution? The fairness question is: how to distribute equitably the captured economic value of intellectual property? Technology is rapidly changing the answers to such questions, challenging conventional wisdom about reproduction and profitability.

The existing paradigm for selling artistic output depends primarily upon three factors: celebrity (scarcity of talent), volume (maximum individual

[1] Goldman 1992.

[2] Madden 2004; Webb 2004.

consumption), and price (gauged to maximize volume for entertainment and to appreciate for fine art). Celebrity artists and the businesses that represent them benefit from the winner-take-all scarcity model that limits facile access to multiple distribution channels by artists and consumers. The market rewards the added value of curatorial and commercial services that select, fashion, and differentiate hits from flops. Brands and celebrity are here to stay. Yet new technologies enable consumers to play a more direct role in such processes of sifting, identity, and branding.[3] This is the complex future of "aura" in the age of digital reproduction. The majority of artists and consumers stand to benefit from the new opportunities that digital technologies offer for accessing infinite copies of infinite artistic variations.[4]

A class structure with a definite materialist basis divides the interests of celebrity and emerging artists, but there are also commonalities and American-style fluidity that foil permanent proscriptions for change. These distinct interests are often oppositional, but they can also coexist and prosper in unexpected ways. More than a dozen international celebrity musical acts [**PLATE 79**], for example, participated in a *Wired Magazine* CD that allows free file-sharing of their tracks through an innovative license from Creative Commons, the non-profit founded by leading copyright activist Lawrence Lessig of Stanford Law School.[5] American artists and arts organizations must adjust individualist priorities to appreciate the benefits of such novel legal and commercial constructs. This is a matter of moving beyond the deployment of reproduction technologies for creating celebrity and managing brands, to expanding markets with innovative strategies for negotiating unlimited selection. New technologies allow artistic creativity and public appreciation to grow simultaneously at the rarified heights of celebrity scarcity and the murky depths of amateur-to-amateur abundance.[6]

[3] Neumeier 2003.

[4] Tompkins 2004.

[5] Goetz 2004.

[6] Hunter and Lastowka 2004.

Such market-expanding impacts can be strangely counterintuitive. Blogs increase book consumption.[7] iPods increase record consumption.[8] At the lower end of gavel prices, original paintings and sculpture usually decline in value, but that is also the price range for the most profitable multiples and prints. At the opposite end of the market, the most expensive original art appreciates the fastest (as also happens with real estate); whereas, the rarest, most valuable prints are least profitable.[9] You can find $40,000 Picasso crayon drawings languishing online, while a Damien Hirst "Opium" print that was snapped up for $750 online in 2000 fetches $10,000 at Sotheby's in 2004 [**PLATE 80**].[10] Greater reproduction often yields higher values and faster appreciation of originals, because advertising increases the aura of celebrity—be it the Mona Lisa or a soap star. Celebrity rarity is so good for business that it encourages not only mass production but free goods as well, confounding a simple quantity-versus-price calculus.[11] Reproduction highlights its own difference from the real thing, and can educate wider audiences about how mysteriously priceless an authentic experience of the latter can be.[12] It also brings us just a bit closer the limelight's lure.

When Ecast CEO Robbie Vann-Adibé asks "what percentage of the top 10,000 titles in any online media store will rent or sell at least once a month," the answer he is looking for is 99 percent.[13] "Long tails" (infinite shelf-space), "mavens" (tastemakers), "memes" (contagious ideas), "mediated shopping" (choice experts), "culture jamming" (media sabotage), "podcasting" (distributed narrow-casting), "DRM" (digital rights management), "HSS" (hit-predicting software), "syndication" (web content sharing)—the economic, sociologic, and political implications of

[7] Kurlantzick 2004.

[8] The Economist 2004; Veiga 2004.

[9] Artprice 2002; Artprice 2004a.

[10] Enterprise North East 2004; Gordon Blankinship 2005.

[11] Williams and Dash 2005.

[12] Kieran 2004; James 2005.

[13] Anderson October 2004.

infinite reproduction and access require a brave new vocabulary to describe, as well as new formulations and theories for understanding.[14]

PLATES

79. **Anthony Mandler**. The Remix Masters. 2004.
Photograph. The Beastie Boys, from left: MCA (Adam Yauch), Mike D (Michael Diamond), and Adrock (Adam Horovitz). Published in Wired Magazine, Issue 12.11 - November 2004. Courtesy of Wired Magazine.
http://wired.com/wired/archive/12.11/beastie.html

80. **Damien Hirst**. Opium. 2000.
Lamda print, edition of 500, signed, 48 x 43 cm / 18.9 x 16.9 in. Courtesy of Gallery Tagboat, London. http://www.artnet.com/artwork/424073689/_Damien_Hirst_Opium.html

[14] Anderson December 30, 2004; Dery 1993; Gladwell 2000; Humphries 2004; Postrel 2004; Tatchell 2005.

Reproduction: A Political Formula

Here is a simplified equation to represent the as-yet unmet opportunity that the new technologies of infinite reproduction and access can offer the visual arts:

$$\text{GUTENBERG} + \text{MARTHA STEWART} + \text{IPOD} = \text{WARHOL}^{\text{SQUARED}}$$

The printing press showed the world the awesome potential of mass reproduction for cultural and democratic change. Martha Stewart's omnimedia empire showed Americans that contemporary design has an everyday value [**PLATE 81**]. Like Russell Simmons' promotion of Hip Hop onto the top of the charts and into all forms of consumer products, Stewart exemplifies how entrepreneurial exploitation of contemporary media can change consumer behavior and expand markets. Their celebrity brands have the power to knock down entrenched barriers, to eliminate arcane distinctions between high and low tastes, and even to maintain public confidence despite law-breaking pursuits of market dominance (one a "gangsta" at the start; the other, convicted at the helm).[1] The visual arts need similar market expanding forces, not just to catch up with the size and scale of the other arts, but to leapfrog from what is now an almost cottage-industry formation, dominated by non-profits and small family-owned business, beyond the multinational arts and entertainment conglomerates, and right into the post-industrial technological and organizational parameters described by this Twenty-First Century formula.

[1] Simmons 2001; Hays 2005.

The formula calls for something else that currently does not exist (as least not as a widely available consumer product): an iPod® for the visual arts. Apple's iPods (and iTunes) combine technology, law, and economics in an art delivery vehicle with the potential to move beyond celebrity and passing fads, to a previously unattainable diversity of production and consumption. With the internet as its backbone, it seems less likely that the system imbedded in iPod will yield as empty a promise as cable television's early potential for greater media democracy. Warhol's use of reproduction led to his own celebrity and influenced the individual enterprises of numerous artists in his wake. The elements of this formula, in contrast, create a virtual factory for truly limitless creative production and consumption. Everyone can now really have their fifteen minutes of distributed fame—but in a way that offers the technical possibility of dislodging availability from celebrity. Key to emerging artist livelihood, iPod provides an economic model for non-celebrities to get paid.

This formula joins two types of knowledge, the positivist, productive kind realized by technology, and the critical, reflective kind manifested in avant-garde art. The political impact of these technological developments depends not only on who has access to the digital output, but also who can appreciate its meaning. Such outcomes are largely a function of who designs the technology, controls its market applications, and writes the rules for its use. The formula can be used for any purpose, but will its potential to liberate and transform be unleashed by our present political and economic structures of decision-making? Some observers think not, such as *The New Atlantis* editor Christine Rosen, whose article "The Age of Egocasting" concludes that technologies of individual choice such as remote controls, the Walkman, VCR, TiVo, and iPod "encourage not the cultivation of taste, but the numbing repetition of fetish."[2] The latter confirms what we already know and want. Art, in contrast, exposes us to new ways of experiencing the world, which, as teaching artist Eric Booth argues, is exactly what distinguishes art from entertainment.[3]

[2] Rosen 2004/2005.

[3] Booth 2005.

iPods bring art into public spaces, but usually for individual consumption that isolates and distracts, rather than challenging or engaging in any kind of transformative artistic or social process. Yet complex systems yield uncertain outcomes; this is the technological paradox. Conservatives often fear access to an appreciation of wider diversity of cultural inputs, because this can undermine traditional Western standards of taste. Infinity and its relationship with chaos are scary and confusing. Freedom is not safe or predictable. Surely such new technologies of infinite reproduction and access offer at least the possibility of stumbling into emerging terrain, of moving beyond fame and fetish to the rewards of experiencing art and art making.

Reversing the way remote controls led advertisers to product placement (compensation for ad-skipping), new devices such as iPod can inspire art placement in ways that insert creativity into the unlikeliest destinations outside of the gallery-world "white cube".[4] The market-expanding potentials of such smart mob and narrow-casting technologies abound, and can be used towards corporate or anti-establishment hacker ends.[5] One corporate example: Nokia's "Connect to Art" allows its mobile phone customers free downloads of exclusively licensed work by celebrity artists, including Louise Bourgeois [**PLATE 82**], Nam June Paik [**PLATE 83**], David Salle [**PLATE 84**], and William Wegman [**PLATE 85**] (though Nokia claims to limit the number of downloads "to highlight the value of the artwork," another nonsensical digital homage to cancelled plates).[6] At the silly-end is Pac-Mondrian [**PLATE 86**], in which Toronto art group Prize Budget for Boys inserted Mondrian's "Broadway Boogie Woogie" into a Pac-Man game.[7] James Buckhouse's "Tap" downloads a dancing figure onto Palm Pilots for mobile choreography [**PLATE 87**]. Cory Arcangel, cofounder of Beige Programming Ensemble, created NIPod by hacking a Nintendo® game onto an iPod® [**PLATE 88**]. The " Barbie Liberation Organization" [**PLATE 89**] is an older example from the early

[4] O'Doherty 1976.

[5] Wark 2004.

[6] Nokia 2004.

[7] Boxer 2004.

1990s, when artist collective ®™ark inserted subversive art directly into children's toys by switching the voice boxes on three-hundred GI Joes and Barbies, with gender-bending results..

White earphones and cords turn any iPod listener into a walking brand builder, but such technology is also being co-opted by art students, technologists, and political organizers for counter-cultural purposes, melding virtual and real-world activism into hybrids known as "tactical media," "hacktivism", and "video samizdat".[8] These strategies have already changed the landscape of political activism, coordinating anti-free-trade protests and creating the fundraising powerhouse behind the 2004 Howard Dean presidential campaign.

The formula is based on a technological construct, but artists are engaging its market-expanding political implications with low-tech and anti-tech applications as well. These range from free-good surprises, such as Alec Thibodeau's "noney" currency [**PLATE 90**], Peter Walsh's reverse waterworks [**PLATE 91**], Anissa Mack's "pies for passerby" [**PLATE 92**], or Zoë Sheehan Saldaña's "shopdropping" [**PLATE 93**] to innovative retailing such as Mack's Tupperware-like art home parties or Harrel Fletcher's bodega exhibitions [**PLATE 94**], to outright luxury good co-branding, such as the Collage Project at Bergdorf Goodman, the pop-up Comme des Garçons Guerrilla Store, or Takashi Murakami's Louis Vuitton handbags [**PLATE 95, PLATE 96**].[9] Whatever these wide-ranging artistic enterprises might reveal about art, human interaction, and the marketplace, this bottom-line is clear: broader transformative impacts depend upon audience size, which in turn depends upon reproduction and access.

Navigating infinite choice is what freedom and art are all about. This formula contains the seeds to expand the public reach of contemporary art. Artists can use it for any purpose whatsoever, but without mastering the most advanced methods of technological reproduction and access, the

[8] Grether 2005; Gilbert 2004; Curry 2004; Taylor 2005; Garcia and Lovink 1997.

[9] Fineman 2004; Horyn 2004; Trebay 2004; Polsky 2003; Siegel 2003; Howe 2003.

vast majority will be prevented from significantly influencing the popular culture of our times and from reaping financial rewards from their work. Instead, artists of new and old media alike will continue to be left settling on the riches of creativity's non-pecuniary satisfactions, moonlighting to make ends meet, and lining up (by the thousands) for the largesse of a very limited selection of wealthy benefactors. Only with the exploitation (subversive and otherwise) of the new forms of interaction and appreciation offered by the latest technological trends, can contemporary art and artists move beyond individualist "egocasting", to forms of art practice with broader social impact.

PLATES

81. **Save Martha Poster**. nd.
Derived from J. Howard Miller's classic World War II "We Can Do It!" poster, produced by Westinghouse for the War Production Co-Ordinating Committee. According to the National Archives Still Picture Branch: "Of all the images of working women during World War II, the image of women in factories predominates. Rosie the Riveter--the strong, competent woman dressed in overalls and bandanna--was introduced as a symbol of patriotic womanhood. The accoutrements of war work--uniforms, tools, and lunch pails--were incorporated into the revised image of the feminine ideal."
http://www.savemartha.com/rosie_save_martha.jpg

82. **Louise Bourgeois**. You and Me 1. 2004.
Screenshot. © Louise Bourgeois 2004 and Les Films du Siamois 2004. Courtesy of Nokia Corporation. http://www.nokia.com/nokia/0,,65686,00.html

83. **Nam June Paik**. Global Groove. 2004.
Screenshot. An homage to Nam June Paik's classic work "Global Groove". Courtesy of Nokia Corporation. http://www.nokia.com/nokia/0,,65690,00.html

84. **David Salle**. Have a wonderful trip. 2004.
Screenshot. Courtesy of Nokia Corporation. http://www.nokia.com/nokia/0,,65680,00.html

85. **William Wegman**. Trio. 2004.
Screenshot. Artist's statement: "We are a mobile society. Man is doing all he can to push the boundaries that contain us and make us conform to obsolete norms. Today everything is push button. Gone are the days of the rotary phone, the Rotary club, the 78. We need an efficiency expert for the 21st century and Nokia has provided it. I am happy to be a small part of it." Courtesy of Nokia Corporation. http://www.nokia.com/nokia/0,,65683,00.html

86. **Prize Budget for Boys**. Pac-Mondrian. 2002.

Screenshot. Courtesy of Prize Budget for Boys.
http://pbfb.ca/pac-mondrian/pac_mondrian_screenshot.html

87. **James Buckhouse**. Tap. 2002.
In collaboration with Holly Brubach, also with dancer Christopher Wheeldon and programmer Scott Snibbe. Tap was installed at Dia Center for the arts, the Whitney Museum of American Art, and at beaming stations placed around Manhattan through the support of Creative Time, and has since travelled to Boston, LA, and London.
http://www.diacenter.org/buckhouse/

88. **Cory Arcangel (aka Beige)**. Nipod. 2005.
Hacked interactive Ipod® programmed for the Nintendo®. Courtesy of Team Gallery, New York. http://teamgal.com/arcangel/works1/ipod.jpg

89. **®™ARK**. The Barbie Liberation Organization. 1993.
The artist collective switches Barbie and GI Joe voiceboxes, so Barbie says "Eat lead, Cobra" and Joe says "Let's plan our dream wedding".
http://users.lmi.net/~eve/images/dolls.JPG

90. **Alec Thibodeau**. Noney. 2004.
Noney notes are available by offering a trade for goods or services. Transaction proposals are welcome from anyone around the world. Courtesy of Alec Thibodeau.
http://www.noney.net/uncut_front.html

91. **Peter Walsh**. Celebration of the Reversal of the New Croton Aqueduct. 2001.
As part of the first Brewster Project festival, in upstate New York, Walsh reversed the flow of New York City's drinking water, creating an imaginary public works project that included a ribbon-cutting ceremony with Brewster's 83-year-old Mayor, John Cesar, and connected with community concerns over the political and financial control of area resources. Courtesy of Peter Walsh. http://www.peterwalshprojects.us/projects.html

92. **Anissa Mack**. Pies for a Passerby. May 17 - June 23, 2002.
Mixed media installation, Brooklyn Public Library (Central Library, Grand Army Plaza). A project of the Public Art Fund, commissioned through In the Public Realm, a program of site specific proposals and projects by New York artists. Courtesy of Public Art Fund.

93. **Zoë Sheehan Saldaña**. Secret Treasures Peasant Boxer Set (Blue Print). 2003.
Saldaña purchased this item for $9.94 from the Wal-Mart store in Berlin, Vermont, then duplicated the item, copying the pattern, and used matching fabric, thread, and embellishments (such as lace, elastic, ribbon, embroidery, and fabric paint) to make as faithful a reproduction as I could. I inserted the original tags, including the price tag, into my hand-made copy. She returned to Wal-Mart with the duplicate, placed it on the rack, and left the store. Courtesy of the Artist.
http://www.zoesheehan.com/art_work/source/3.html#

94. **Harrell Fletcher**. This Container isn't Big Enough. 2004.
According to the artist: "A free newspaper for the Whitney Biennial. The publication features information about ten different artists who I know from around the country. I worked with a group of student volunteers from Cooper Union who found exhibition venues for the artist's work in various cafes, a furniture store, a library, a senior center, etc. The newspaper gives all of the exhibition information and also describes a project I did for Socrates Sculpture Park, as well as a long list of unused ideas." Courtesy of Christine Burgin Gallery, New York. http://www.harrellfletcher.com/#

95. **Takashi Murakami**. The Double Helix Reversal. 2003.
Coutesy of the Serpentine Gallery, London. http://www.bbc.co.uk/dna/collective/A875171

96. **Takashi Murakami**. Louis Vuitton Murakami Multicolor Speedy 30 handbag. 2003.
http://www.artnet.com/Magazine/features/polsky2/polsky10-10-2.asp

Reproduction: Social Sculpture for the Creative Economy

Art lovers who are confused by the utter diversity and seeming directionlessness of contemporary art are looking to the future in the wrong place. Neither content nor form is the crux of the next art movement, but rather access and understanding. This is the infrastructure that ties Benjamin to Beuys, and moves beyond conceptualism and irony. Walter Benjamin wrote in the first half of the last century that mechanical reproduction reverses the function of art, and "instead of being based on ritual, it begins to be based on another practice—politics." In the second half of that century, Joseph Beuys saw multiples as key to spreading his ideas about social sculpture, or "how we mold and shape the world in which we live."[1] Beuys saw physical reproduction as key to the dissemination of his art, even if evolutionary social processes are the core materials and fundamentally "everyone is an artist." The growth of conceptual art itself was in no small measure tied to strategic publicity and promotion (as was Impressionism in the Nineteenth Century and most other maverick artistic endeavors).[2] The future of art ties new media to old, imbedded with concept, but its growth and coherence depends on systems of reproduction and access.

In his small book on modern art, *Behind the Times*, the economic and social historian Eric Hobsbawm laments the failure of visual artists—unlike their counterparts in literature, music, and theater—to come to terms with the technologies of infinite reproduction. Hobsbawm extends the

[1] Kuoni 1993, p. 19.

[2] Alberro 2004; Cowen 1998.

argument he made in his sweeping historical synthesis, *The Age of Extremes*, that modernism died around 1950 with the rise of popular entertainment.[3] As fine artists cling to unique hand-made objects, the avant-garde is beholden "to a society of patronage or of small groups competing in conspicuous expenditure, and indeed these are still the foundation of the really lucrative art trade. But it is profoundly unsuited to an economy which relies on the demand not of single individuals or a few dozens or scores, but of thousands or even millions; in short, to the mass economy of this century."[4] While Hobsbawm puts his finger on the weakness of contemporary art as a social venture, he undervalues how crucial is the particular physicality of aesthetic experience. A digital renaissance in visual art must invent that connection: highly reproduced accessibility for personal physical engagement with art. The point is worth repeating: reproduction is the mass entry point for artistic experience. Arthur Danto, for example (who dates the "end of art" a decade-and-a-half after Hobsbawm does), recalls how a chance war-time exposure to a poster of *La Vie*, Picasso's blue-period masterpiece, gave a young solder in the Italian campaign the determination to see the original. Decades later, this now-famous art critic credits his "entire involvement with painting" with that accidental encounter with a reproduction, far from the sheltered galleries of a museum authenticity.[5]

In national polls, 96% of Americans say they are greatly inspired or moved by art, but only 27% say artists contribute "a lot" to society.[6] This dichotomy captures the fundamental failure of contemporary art in America. Dependent financially on a market focused on the wealthiest elite buyers, art making has lost touch with the significance of public appreciation and understanding. The political import of social sculpture barely makes a peep outside of art schools, white cubes, and the occasional metropolitan public art curiosity. Popular tastes are regularly ridiculed and demeaned. Art education is removed from public schools.

[3] Hobsbawm 1996.

[4] Hobsbawm 1998, p. 17.

[5] Danto 1997, p 179.

[6] Jackson et al. 2003; Princeton Survey Research Associates 2003.

Cutting edge means esoteric. User-friendly explanations defy minimalist "in-the-know" exhibition standards. Arts funding is a sitting duck in partisan culture wars. The bottom line: artists cannot make a living, in a self-fulfilling mythical prophecy rooted in twisted biblical moral aspirations. The dominant counter-culture ethos of contemporary art starves its own practitioners and robs the greater public of a broader understanding of the values of art making in our daily lives. The combination of appreciation-oriented collector demand and anti-establishment artistic supply has reduced the visual arts to a minor appendage to the massive arts and entertainment industry.

Visual artists are at the "super-creative core" of America's post-industrial economy as described by Richard Florida in his influential 2002 book *The Rise of the Creative Class*. Yet rather than commanding the avant garde of the 38-million strong "creative class," artists are instead leading only themselves further and further from the mainstream. Moving so fast to satisfy the cult of innovation, rarely do contemporary artists stop to explain their work in ways that relate to the lives of millions of fellow creative professionals, let alone the public at large, engendering a new kind of class divide that alienates artists from their broader community. Advanced degrees are now not only necessary to survive in the art world—with the MFA being the new industry standard—you also need one just to understand and appreciate much of the work being produced. The most obvious manifestations of this gap includes declining media coverage and declining funding from all sources for fine arts organizations and individual artists.[7] As recently as the early 1990s, visual artists received 20% of federal arts grants to individuals, the same as their share of working artists in all disciplines. Today, visual artists receive absolutely nothing, nada, zip. Direct grants to all individual artists, moreover, are now less than 1% of the National Endowment for the Arts' budget.[8]

[7] Szántó et al. 2004; Lowell 2004.

[8] Galligan and Cherbo 2004.

To working artists exhibiting in local venues outside of the glamorous art centers, it can often seem as though no one is interested in contemporary art. When culture wars flare, there is barely any public outcry. Moral crusaders freely act as though the arts defile family values rather than create them, examine them, and explore them at depths untouched by any other human activity, except, possibly, philosophical and religious contemplation—which, since even before the *Diamond Sutra*, have always relied on the visual, literary, and performing arts for their public expression. Many artists cringe at the thought of appealing to market demand, which is often seen as uninspiring, even ignorant, and pandering to a money-grubbing capitalist mentality unworthy of loftier artistic pursuits. Better to mock and critique mainstream currents of American culture than to fall prey to its superficiality or destructive imperialism. Irony is far safer for art-world credibility than selling out to the invisible hand. Mass-marketing art engagement can seem no more sophisticated than a newfangled coloring book, etch-a-sketch, paint-by-number, fuzzy wuzzy, or colorform, rather than like transformative social sculpture. Local artists and arts administrators often dread corporate approaches to art making, such as pre-fabricated stenciled tarps for large-scale public art projects.[9] Yet, as Dave Hickey points out, "the language of pleasure and the language of justice are inextricably intertwined."[10] And as McLuhan proclaimed advertising to be the last century's greatest art form, contemporary art had better internalize the seductive functions of corporate advertising if it wants to compete for the public's already-overwhelmed attention-span in the next century.

The concepts of an ascendant creative class and economy indicate how the notion of social sculpture can operate on a societal scale. Contemporary art will never capture the public's imagination merely as art for arts sake. Nor will instrumentalist arguments ever convince the public to experience the transformative powers of aesthetic experience, no matter how many studies prove art is great for economic development, educational performance, and building moral values. Neither partisan

[9] See, for example, www.monstermural.com.

[10] Hickey 1997, p. 169.

politics nor financial gain will move art onto a larger platform of public appreciation, despite the most strongly held passions against war and enthusiasms for discovering under-valued talent. Art frames infinity. It is our closest contact with freedom. It is the miracle of creation in human form. It inspires us to live. Artistic creativity is essential to life, liberty, and the pursuit of happiness. These are among the most deeply held American values, yet somehow the intimate relation to artistic experience of such Jeffersonian aspirations has been lost in the public's eye.

This is why reproduction is key to the future of art. Reproduction is necessary for renewability; without it, there's extinction. Reproduction is essential for visibility; without it, there's indifference. There are no limits to the growth of creativity—only a lack of advertising. Such growth is incremental and requires constant nurturing. Lack of accessible exposure, daily encounters, opportunities for engagement—that is what ultimately undermines public support for the arts: the lack of reproduction connecting to what audiences are ready to hear. Addressing this challenge requires more than clever tactics and innovative use of media. The task is far more complex than bloggers spreading funny but false rumors of Thomas Kinkade and Jeff Koons mergers acquiring rights to artworks by Maurizio Cattelan [**PLATE 97**] that will be merchandised on Glade® holiday candles [**PLATE 98**], along with Kinkade's own images.[11] Rather, it means strategically rebuilding the contemporary visual arts market into a powerhouse that can compete with the giants of the multinational arts and entertainment industry. It means changing the way art insiders think about reproductions as product and reproduction as process. Looking back, this is why centuries of disciples—forgotten assistants and unquestioned geniuses alike—first experienced art by making copies. Looking forward, it means understanding the political economy of intricately contested markets for infinitely reproducible intellectual property in the digital age.[12]

[11] Capps 2004; Coleman et al. 2004; Gibson 2004.

[12] Union for Radical Political Economics 2004.

PLATES

97. **Maurizio Cattelan**. La Nona Ora (The Ninth Hour). 1999.
Courtesy Anthony D'Offay Gallery, London.
http://grammarpolice.net/archives/images/cattelan.jpg

98. **S.C. Johnson & Son Inc**. Glade® Holiday Candles. 2004.
© Thomas Kinkade, The Thomas Kinkade Company, Morgan Hill, CA.
http://www.glade.com/holiday.asp#1

Reproduction: Genesis of the Next Art Movement

Many visual artists are grappling with the import of revising the discipline's historical animosity toward reproduction, including practitioners of older media with strong traditions of limiting editions as well as the most innovative new media pioneers. Brooks Jensen, editor of the fine-art photography journal *Lenswork Magazine*, for example, writes "I am against a predetermined limit imposed as a strategy to make the artwork scarce. I am now prepared to say that '1/250' is a bunch of bull."[1] In their book *Digital Resistance*, the collective known as Critical Art Ensemble cuts to the chase:

> Individual cultural producers are worried about being denied compensation for their work due to unbridled duplication. This is a false anxiety. Unless an artist is transformed into an institution, there is no need to worry.[2]

One member of the collective may be approaching such celebrity status, because of international outrage over a federal anti-terrorism investigation and charges of mail and wire fraud. Steve Kurtz, a University of Buffalo professor, co-founded CAE, which engages in tactical media projects that explore precisely the nexus of technology,

[1] Jensen 2001.

[2] Critical Art Ensemble nd.

biology, reproduction, politics, art, and critical theory. On May 11, 2004, after Kurtz discovered his deceased wife, emergency responders called the FBI, who allegedly found in addition to the body a DNA-extraction laboratory (designed for exhibition at the Massachusetts Museum of Contemporary Art) and bacteriological strains (acquired for other art projects). Despite subsequent worldwide publicity and fundraising efforts for Kurtz's legal fees, a notice on the CAE website still says that writings on the site "may be freely pirated and quoted."[3]

Copyright protections are written into Article 1 of the U.S. Constitution to "promote the progress of science and useful arts." The original intent was a constitutional incentive for American creativity balanced with the public's interest in freedom of information. But as intellectual property has become the driving force of our economy, its largest corporate owners have successfully lobbied Congress over the years since this country's founding to extend the reach of copyright's private claims. A new generation of artists, scholars, and activists is questioning the increasingly restrictive corporate and legal limits to artistic reproduction. This legal abstraction contains the paramount challenge to creativity of our day. The stage is set for an historic conflict between artistic production and derivation, once homage, now transgression. Yet most visual artists have only the slightest understanding of the stakes, or, for that matter, what actually is and is not permissible under federal and international copyright law.

It is hard to imagine the look of art history if current intellectual property law had always reigned. Sitting in a café sketching the view, today's artist could be violating rights with every mark: the stylish logo on the menu, the striking architecture outside the window, the chic light fixtures dangling from the ceiling, the retro posters on the wall, the haute-couture handbag leaning on the bench, the designer eyeglasses resting on a forehead, maybe even the signature hairstyle—in every direction, every object and sign, all of the recognizable imagery could be intellectual property owned by a corporation or individual.

[3] Ibid.

Leading intellectuals are calling for a new "cultural environmentalism" that champions our endangered creative commons and galvanizes a broad social movement to protect it.[4] A growing list of organizations and websites are dedicated to the cause, including: AdBusters (www.adbusters.org), Copyfight (http://www.corante.com/copyfight/), Copyleft (www.copyleftmedia.org.uk), Creative Commons (www.creativecommons.org), Critical Art Ensemble (www.critical-art.net), Electronic Frontier Foundation (www.eff.org), Free Expression Policy Institute (www.fepproject.org), Freeculture (www.free-culture.org), Grey Tuesday (www.greytuesday.org), IPac (www.ipaction.org), Joywar (www.newsgrist.org), Lawrence Lessig (www.lessig.org), Public Knowledge (www.publicknowledge.org), and *Stay Free Magazine* (www.stayfreemagazine.org).

These efforts bring us back to the Renaissance, close to where this examination of reproduction first begins. In the middle of the Sixteenth Century, Norfolk rebels established the first English Commonwealth in Norwich, with elected delegates and governors, after uprising against enclosures that fenced off communal lands and turned them into private property for wealthy lords. For many historians, the English enclosure movement marks the birth of modern capitalism. It is also often cited as the precursor of modern environmentalism, as this anonymous poem indicates why:

> The law locks up the man or woman
> Who steals the goose from off the common
> But leaves the greater villain loose
> Who steals the common from off the goose.[5]

Scholars such as Duke University law professor James Boyle, see a second enclosure movement afoot; although, this time involving "intangible

[4] Boyle 1997; Boynton 2005.

[5] Boyle 2003, p. 33.

commons of the mind."⁶ The parallels run deep. Sir Thomas More (1478-1535) argues in *Utopia* (1516) that the first enclosures were not only unjust, but the cause of economic inequality, crime, and social dislocation. But More's utopia is far from the vision of a gift economy promoted by artists and internet cyberpunks alike. In his *Confutation of Tyndale's Answer* (1532), More would rather consign English translations of his own *Utopia* to flames than allow a broader readership (his original was in Latin). He was one of the most prominent advocates for burning William Tyndale at the stake, and for burning all of the popular preacher's English translations of the bible. Neither More nor Martin Luther supported peasant rebellion to such an extent as to challenge authority, private property, or the privilege of knowledge so radically.⁷

Like ecology, creativity is robust yet fragile. Unlike land, however, imagination is an infinite resource. That does not mean its products should always be free; if they were, the creative economy would not exist, and no artist, scientist or other creative professional could earn a living. But it does mean every artist and every person whom the arts have ever touched needs to influence the dialogue that sets the boundary between public and private domains: that is, who can reproduce what, how, when, where, and why. Otherwise, and without doubt, corporate lobbyists will continue to restrict the creative commons that in the past has offered everyone the raw materials for artistic production. Understanding the profound connection of reproduction to freedom and survival—as individuals, citizens and artists—provides a basis for a new art movement with the breadth and strength to move the arts forward. The terrain for exploration is as old as the first stenciled hand prints and as culturally rich as humanity itself. Protecting the diversity and fertility of these soils, and bringing its harvest to a broader public is the calling of the arts in the Twenty-First Century.

⁶ Ibid, p. 37

⁷ Baker 1996.

Reproduction: Bountiful Opportunity

Imagine an America in which the art market was proportional to the percent of visual artists out of all professional artists working in every discipline. If the arts and entertainment economy reflected this allocation, the visual arts would command as much as 20% of that market—a fivefold increase over its current meager 4% share. Visual arts would generate sales of $150 billion, placing it in the range of massive media and literary arts industries (though still more modest in comparison). Instead of a paltry $700 annual average income directly from making visual art, every working artist in America would earn over $10,000 from sales of and grants for their work each year. While certainly not a living wage, this level of reimbursement would provide a real financial incentive to contribute to the culture of American democracy. The very unromantic reality of the unpaid artist would begin to fade into the past.

If you think this is just a crazed megalomaniacal artist fantasy, you may be unaware of the fantastic difference between the popularity of visual arts in America and its utter lack of financial returns. With all of the glitz and glamour of international art fairs and auction extravaganzas, the $12 to $30 billion estimates of the U.S. visual arts market may at first seem quite substantial.[1] A quick comparison with the $550 billion U.S. media entertainment business—already twenty times larger than the visual arts market and expected to reach $680 billion by 2008—puts the commercial slices of the arts pie in better perspective.[2] More conservative estimates would put the literary arts at $114 billion and the media arts at $173

[1] Unity Marketing 2003; Goldman 2005; Saltz 2005.

[2] PricewaterhouseCoopers 2004.

billion, but the point remains: visual arts revenues are an order of magnitude smaller than those in the other major arts sectors.[3]

There are at least two obvious possible explanations for this gross discrepancy in the market sizes of the various arts and entertainment sectors. First, there may be fundamentally lower human demand for visual art than for sounds, words, and motion pictures. Second, the demand for visual art may exist, but some form of market imperfection is preventing its realization in financial terms.

Only one number can dispel the first hypothesis: 77. That is the millions of adult Americans who want more visual art in their lives, almost 90% of those who attend visual arts events each year, and a stronger preference than voiced for any of the other arts. Here are three more numbers, if more convincing is needed: 86, 80, and 61. Those are the total Americans in millions who attend visual arts events, make visual art, and buy visual art each year (respectively). That means 2 out of every 5 adults in America are actively and demonstrably interested in the visual arts—a higher percentage than attend spectator sports, live performances in all other artistic disciplines, or than participate in outdoor recreation, or even than is necessary to win an election for President of the United States! Audience participation is growing faster for visual arts than for all other out-of-home leisure activities surveyed by the U.S. National Endowment for the Arts.[4]

Only one number can show how disconnected is public appreciation for visual arts from artist remuneration: six-tenths of a percent. That is roughly the fraction of a percent of Americans who make visual art that the Bureau of Labor Statistics counts as professional working artists (fewer than 500,000 out of 80 million). It is also roughly the fraction of a percent of all visual artists who display their work in public that can make a living at it, even if only a $20,000 meager annual average (20,000 out of 3.3 million artists). And it is also roughly the fraction of a percent of

[3] Goldman 2005.

[4] National Endowment for the Arts 2004.

all professional working artists who are lucky enough to be represented by a viable commercial gallery, the key to making a career from art sales (3,000 out of half-a-million artists).[5] Despite all of the positive trends in visual arts appreciation, the picture for visual artists is getting worse: they are the only discipline of art workers whose full-time employment opportunities have been declining since the start of the Twenty-First Century (by -7% from 2000 to 2003). For performers and writers, in comparison, full-time employment is on the rise (by +8% and +10%, respectively).[6] Six-tenths of a percent! That is not a meritocracy; it is the most extreme indication of culture that fails to reward the working artists who create it.

There are plenty more statistics indicating that the magnitude of demand for visual art is within reach of the other arts, and certainly not at a fundamentally lower plane. The intent of such comparisons is not to pit art disciplines against one another. On the contrary, it is to learn from each other. What the other disciplines can teach the visual arts is that reproduction is good for business. That is the most obvious pervasive structural difference that differentiates the visual arts from the rest of the arts and entertainment industry. Demonstrating the strength of the market imperfection hypothesis is not as simple a matter as a few compelling data points; but rather, it requires an articulation of the rich historical influences that created the visual arts' exceptional economic trajectory. This analysis also suggests that rather than harming the other disciplines, a more prominent economic role for contemporary visual arts and its living artists could well be the best thing that has happened to arts in general for a very long time.

Exclusivity is the culprit creating the visual arts' economic stranglehold, artificially restricting its own market opportunities. When former Metropolitan Museum of Art director Thomas Hoving says "art is sexy! Art is money-sexy-social-climbing-fantastic!" he is speaking to

[5] Goldman 2005.

[6] Nichols 2004.

motivations that are far from limited to the wealthiest cohorts of society.[7] The consumer masses love whatever connection to luxury they can afford.[8] Such aspirational marketing has been embraced through reproduction by the rest of the arts and entertainment world as well as by retailers worldwide, but in the visual arts, the arms-reach approach to exclusively unique artifacts still applies. If you have to ask, you can't afford it! Or, conversely, if you can't get what it means, don't ask! Ironically, the rationale for the lack of reproducible marketability comes from the extremes of both capitalist and anti-capitalist ideologies that dominate the visual arts. On the one hand, there is the investment-oriented appreciation approach of the market-leading businesses, which prize scarcity; on the other, there is the gift-economy radicalism of academics and grant recipients, who value the transformative impacts of alternative ways of engaging the world.

One more statistic points beyond this complexly rooted, self-limiting, anti-consumerist, anti-reproductive bias of the visual arts economy, and points to what the visual arts can teach the other arts and the culture at large: 93. That is the percentage of Americans who personally make visual art for themselves relative to those who go out to see it. That is social sculpture writ large. That is the democratic essence of the visual arts. Everyone is indeed an artist.

Still worried about market saturation? That is, the macro-economics of oversupply as opposed to the micro-economics of overexposure, the dilution of price when talent is ubiquitous? Just because everyone can benefit from engaging in creativity does not mean that everyone has identical talents for producing works of visual art. Don't forget the two billion walls in American homes—all of which offer opportunities for display. There are 4,000 residential walls for every working artist in America. Add to that the hundreds of millions of more walls in non-residential spaces, including offices, stores, and other public and private facilities. Many of these walls have space for multiple works. And who

[7] Cited in Buck 2004, p. 38.

[8] Frank 2004; Rozhon 2004.

says that the art cannot change over time—especially when reproductions are involved—according to the changing interests of those who live and work within those walls? This is not just an echo of the fashion season, itself an exciting renewal of energy, but more profoundly, can reflect the developing sophistication of aesthetic appreciation as consumers mature. This process can only occur by living with art.

It often seems that there are thousands of artists lined up to compete for every opportunity to exhibit work. But the real truth is that for every working artist in America there are literally thousands of opportunities to exhibit art. And that includes only the two-dimensional indoor opportunities. Outdoors, they are unlimited, as Christo and Jeanne-Claude's 7,500 Gates [**PLATE 99**] in Central Park illustrate on the grandest scale, paid for with the sale of $20-million worth of prints and other multiples, a classic case of how reproduction increases the profile and value of originals.

Still worried that art will be reduced to decoration? How self-defeating and hypocritical it is to chase wealthy collectors with beautifully radical art statements while abhorring the commodification necessary to bring art into the daily lives of the general public. How much more subversive would it be if instead of academic leftism, engaged in obscure philosophical debates and clever virtual pranks, artists subvert the elitist price-appreciation model of the art market, not with utopian free-goods that prolong the starving-artist myth, but rather by infiltrating the homes of Americans with objects of transgressive beauty?[9] Why not embrace the democrat aspect of commodity capitalism, acknowledge the new aura is branding, and use these insights for more than celebrity promotion, for the infusion of contemporary art into the intimacy of Americans households? That is the opportunity, and it is bounteous indeed.

The statistics show that Americans want more visual art, more visits to museums and galleries, and more often than they want any other form of art exposure. Let's bring it home!

[9] Hickey 1993.

VISUAL ART INDEX

Who Wants to See Art?

Millions of Americans who attend museums, galleries, art fairs or festivals events each year : *86*
Millions who want more such visits (preferred more strongly than all other arts) : *77*
Number of Americans who attend visual arts events for every 10 who read fiction or poetry : *9*
Number who attend visual arts events for every 10 who go to the movies : *7*
Percentage of all adult Americans who attend visual arts events each year : *42*
Percent who attend spectator sports : *35*
Percent who attend live music, theater or dance : *32*
Percent who participate in outdoor recreation : *31*
Percent who voted for George Bush in 2004 : *30*
Percent growth in museum and gallery goers (highest surveyed leisure activities, 1982-2002) : *+20*
Twenty-year percent change in adult viewers of movies : *-5*
Percent change in adults who read literature : *-18*
Percent change in adults who attend spectator sports : *-27*
Percent of Americans with graduate degrees who visit museums and galleries (a majority!) : *59*
Visits that Americans made to museums and galleries versus theaters and music venues : *2.5:1*
Fraction of all performing arts attendees who also visit art museums : *>1/2*
Percent of Americans who watch visual art TV shows (more than any performing arts broadcast) : *25*
Percent of Americans in Mountain states who visit museums (more than East and West Coasts) : *34*

Who Wants to Buy Art?

Millions of Americans who buy original works of art : *61*
Odds that a museum or gallery visitor bought art in the last year : *4 out of 5*
Percentages of both adult men and adult women who buy art each year : *30*
Age group with the highest percent of adults buying art (41%) : *18-24*
Percent of Latino Americans buying art each year (highest for any race or ethnicity) : *38*
Percent of Asian and Native Americans visiting museums (highest for any race or ethnicity) : *33*

Who Wants to Make Art?

Millions of Americans who make visual art (paint, draw, photograph, pottery, jewelry, textiles) : *80*
Americans who make art as a percent of those who attend visual arts events : *93*
Who perform as a percent of those attending performing arts events : *40*
Who do creative writing as a percent of those who read literature : *15*
Ratio of Americans who make visual art to those who write fiction or poetry : *5:1*
Ratio of Americans who make visual art to those who practice theater, music or dance : *3:1*
Millions of Americans who sing chorale music in public (most frequent public art performance) : *9.9*
Millions of Americans who paint or draw for public display (second most frequent) : *3.3*

Who Wants to Live off Art?

Millions of visual artists work in America (art directors, fine artists, animators, photographers) : *<1/2*
Percent more working visual artists than writers and authors : *90*
Percent more working visual artists than musicians, actors, and dancers : *10*
Percent change in full-time employed writers from 2000 to 2003 : *+10*
Percent change in full-time employed performers from 2000 to 2003 : *+8*
Percent change in full-time employed visual artists from 2000 to 2003 : *-7*

Who Says so?

U.S. National Endowment for the Arts 2004 (*Research Note #87* and *Research Report #45*).

PLATES

99. **Christo** and **Jeanne Claude**. The Gates, Project for Central Park, New York City. 2002.
Drawing. © Christo. http://www.wolfgangvolz.com/Gates.htm

Reproduction: The Future of Art

Imagine an America in which the visual arts take their rightful place as an economic force in the massive arts and entertainment industry. With the consequent five-fold increase in market size (and growing!), there is a quintupling of cultural impact. When culture warriors try to shove artistic exploration back into a bottle, myriad voices proclaim the centrality of art's freedom-loving pluralism to American values. When special interests try to restrict public access to creative assets, an army of enthusiasts demonstrate the importance of balancing private rewards for the hard work of innovation (and interesting derivation!) with spreading the benefits of culture for the greatest good.

Americans treasure the role that visual arts play in their lives, and reward the workforce of artists who provide the experience. Art participation is tied directly to artist appreciation, because the public is repeatedly reminded about creators of the work, not only by celebrity appearances, but by artist signatures on every wall. Art marketing that introduces the artists behind the art is as ubiquitous as advertising, with insightful explanations and demonstrations of artistic goals, methods, and biographies. A young person wanting to become an artist is no longer a parent's worst nightmare, but rather, brings to mind numerous lifestyle choices and career opportunities that are both viable and enviable.

Artists are everywhere: teaching in schools, invigorating workplaces, exciting our homes, planning waterfronts, challenging television viewers,

revitalizing coffee-shops, even running for public office [**PLATE 100**].[1] Fighting for the arts is no longer seen as a partisan interest. Conservatives and liberals loudly champion their diverse artistic interests. The mix of art and politics no longer just means learning which movie star favors which cause, nor still having to demolish the restrictions and biases of the past. Art has become integral to diplomacy, with cultural exchanges facilitating international relations and diminishing conflict throughout the world. American governmental entities at all levels fund a vast variety of artistic endeavors that are integrated into all aspects of American life, from local economic development to national education policy to significant public spaces. These investments are more than matched by all manner of private-sector contributors with specific and general interests in the outcomes.

In sheer financial terms, the art market's biggest changes have taken place in the private sector. The for-profit visual art industry is one of the leading innovators in intellectual property, new media, retailing, and finance. A new generation of corporations has emerged, as well as innovative visual arts divisions of existing corporate entities. Artists engage in a range of commercial relations with companies and consumers [**PLATE 101**]. Like musicians who receive contracts for live performances and royalties from record sales, visual artists have developed different arrangements for exhibiting and selling original work, and distributing reproductions for mass consumption. Contemporary art has become as prevalent in the marketplace as Sanrio's "Hello Kitty" was at the start of the century.[2] Creativity has become America's brand name, and artists are the recognized experts, consulting for organizations in all sectors of the economy.

Government decision-makers who need measures of accountability to justify their actions to voters understand that cultural investments are not merely unquantifiable aspirations or politically controversial aesthetics. Rather, politicians and bureaucrats are well aware that areas of legislation

[1] Tresser 2004; Chatman 2005.

[2] Gomez 2004.

and budgeting involving the arts and all other forms of intellectual property are critical to all aspects of economic performance, from local community development to international competitiveness.

Federal tax deductions for charitable donations of art, which had been the hidden driver of escalating art prices and the growth of non-profit arts (the largest source of museum income and equal in value to the entire on-the-books private art market) are finally offered to artists themselves.[3] This ends one of the longest-standing inequities in the arts industry, with origins in the financial shenanigans of cash-strapped European aristocrats and the *noblesse oblige* of Post-War American industrialists, and led to the formation of the Art Dealers Association of America and IRS-backed appraisal standards.[4] Previously, unlike everyone else who donates art, artists were only allowed to deduct the generally worthless tax value of materials and supplies. Opposition to resale royalties for artists also finally gave way, many years after the European Union had agreed in 2001 to harmonize standards of *droit du suit* (rights of resale).

Non-profit arts have been transformed from the ground up. Starting with educational institutions, the arts have been thoroughly integrated into the curriculum after years of corroborating evidence that the skills, confidence, and thinking strategies developed through artistic expression help with the basics of reading, writing, and arithmetic—not to mention test scores, readiness to work, technological innovation, teamwork, and positive attitudes about life in general. Undergraduate and graduate art schools, in turn, integrated their curricula with other areas of programming throughout the educational community. The expansion includes a range of fields relevant to professional development beyond the craft and thought needed for exceptional artistry. As a result, when artists enter the workforce, they are broadly trained in how to market and apply their abilities both within and outside of the traditional world of art galleries and alternative exhibition spaces. In particular, artists understand that that shunning reproduction means forfeiting two-thirds

[3] Fullterton 1991; National Endowment for the Arts 2004, p 2.

[4] Morrison1996; Kallir nd.

of the potential income from their work. Despite meteoric growth in demand for original work by hot contemporary artists, sales of reproductions continue to accelerate even faster, just as they had during the prior century.

Not-for-profit arts organizations have adapted their missions and staked out new territories to catalyze and accommodate growing and more sophisticated demand. Like the rest of the non-profit community, they have aggressively and creatively diversified their income sources, applying their core competencies to commercial alliances and community services in ways previously unimagined.[5] They internalized the results of the Urban Institute's turn-of-the-century report on artist working conditions, and focus their activities not only on showing the most innovative artwork, but also on building much-needed artist infrastructures and expanding the markets for art and art making.

Twenty-First Century social enterprises such as Boston-based Leveraging Investments in Creativity and New York-Based Mutual Art, working in alliance with both fledgling and established organizations around the country, have pioneered artist pension and medical insurance plans, artist live-work real-estate developments, artist employment and grant information systems, international cultural exchanges, and even creative retirement homes. The earlier entrepreneurial influence of museum stores (especially their positive impact on institutional growth and survival) has spread to all non-profit arts organizations in diverse and unexpected ways. The cornucopia of new financial arrangements for putting art out into the world include leases, loans, licensing, consignments, merchandizing, sharing, bartering, and too many other forms of transaction to mention. The standard organizational model has changed from how to get audiences through the doors, to how to get artistic experiences into all aspects of life, work, play, and community.

As a result, cutting-edge contemporary art is seen everywhere, and artists are getting paid for the privilege. Universities and other large institutions,

[5] Shuman and Fuller 2005.

as well as small, medium and large businesses in all sectors of the economy routinely budget for and pay artists and their agents to provide and install works for exhibition. Artists not only receive shares of the proceeds from their shows, they also earn royalties from a variety of uses of their original and reproduced art, as well as fees for creative work in a wide range of academic, corporate, government, and social-service settings. National artistic professional development agencies such as Creative Capital not only recruit corporate strategists to train emerging artists in the skills of success, but they are also placing exceptional artists in board rooms to inspire creativity. The innovations of avant garde creative artists and non-profit arts organizations are models for culture workers and professionals in numerous other fields, who, like artists, often work independently for multiple employers, solving problems and providing value based on talent, experience, and training.

There are bold new non-profits involved in strategic arts advocacy. After receiving an unprecedented $120 million gift from billionaire pharmaceutical heiress Ruth Lilly in 2002, the Washington-based Americans for the Arts finally achieves its goal of becoming a household name, claiming its ground as the "Sierra Club for the arts." With more museum goers than outdoor recreation enthusiasts, Americans see a proliferation of arts advocacy groups that are as well recognized for grassroots and international activism, lobbying, litigation, and research as the constellation of famous environmental groups that existed at the start of the century, including the arts equivalents of Greenpeace, National Wildlife Federation, Earthfirst!, World Wildlife Fund, Audubon Society, Nature Conservancy, Environmental Defense, Natural Resources Defense Council, and so on. The arts advance all of the media strategies that environmental organizations had so successfully developed in the past, from children's *Ranger Rick* magazines to *Rainbow Warrior's* daring at-sea protests. Visual artists have established the largest arts union in the country to set a range of industry standards, negotiate fair compensation, and join in a variety of advocacy and lobbying efforts.

These pioneering arts advocacy organizations achieve tremendously influential synergistic effects by collaborating with non-profits working in

diverse areas, including, for example, environmental groups and information activists. The resulting heightened level of civic engagement leads millions of Americans to actively support a new kind of cultural environmentalism that expands our creative commons. Artists understand their role as "cultural citizens" (to use the phrase of Theater Communications Group director Dan Cameron) is critical not only for their own livelihoods, but for protecting and nourishing American culture at large.[6] For the first time in decades, multi-disciplinary public intellectuals abound, spurred by the blogging bonanza that began the century.

The art world no longer resembles the anemic state that led to the classic economic formulation of William J. Baumol and William G. Bowen, who saw the fine arts as suffering from a "cost disease," unable to incorporate the labor-saving technological advances needed for financial viability.[7] This seminal hypothesis launched the field of cultural economics, and concluded that government subsidies and private donations were the only means by which the arts could survive in a cut-throat capitalist world.[8] Not even mass media would cure the affliction.[9] As it turns out, the exact opposite was the case, fine artists are showing the rest of society how to reorient the economy towards sustainable creative ends, and are deploying the most advanced technologies for transforming contemporary culture. As Joseph Beuys put it in 1985: "the two genuine economic values involve the connection between ability (creativity) and product. That explains the expanded concept of art: ART=CAPITAL."[10] **[PLATE 102]** At its core, the symbolic capital generated by the arts is infinitely reproducible.

No one thinks deprivation helps creativity anymore; the myth of the starving artist has become a distant memory. Individualism and

[6] Jacobs 2005.

[7] Baumol and Bowen 1965.

[8] Besharov 2003; Towse 2002.

[9] Baumol and Bowen 1997.

[10] Beuys 1985.

overexposure, the other specters of the self-imposed mythical triumvirate that had kept visual artists from engaging the broader public, have also been dumped from their thrones as leading preoccupations of working artists. Reproduction in the visual arts is seen as a profound social process, not a second-rate product. Procreation. duplication, repetition, imitation, simulation, replication, copies, parody, simulacra, cloning— these are the seeds of artistic evolution and expansion that have led to the new renaissance. Artistic innovation has reached exponential rates and its impact on society at large has become truly transformative. Communication, difference, freedom, truth, justice, beauty, suffering, humor, subversion, mystery, awe—there is no end to the traditional and novel motivations expressed in the work of the ever growing numbers of visual artists. They are the indeed the avant garde of the creative society, and the public is following their lead.

Artists of the world: MULTIPLY!

PLATES

100. **Danny Tisdale**. An Artist for a Change in New York City. 1996.
Podium, wall text, microphone, campaign photograph, NY State and U.S. flag. Campaign headquarters one person installation at Lombard/Freid Fine Arts Gallery, New York.
http://www.franklinfurnace.org/tfotp00/tisdale/change02.html

101. **Bill Watterson**. Calvin and Hobbes. 1990.
Courtesy of Universal Press Syndicate.
http://www.law.harvard.edu/faculty/martin/art_law/market.html (Accessed: February 8, 2005).

102. **Joseph Beuys**. Kunst = Kapital (Art = Capital). 1980.
Screenprint on blackboard, wood. Courtesy of Walker Art Center, Minneapolis.
http://www.denison.edu/library/class/ARTH284-sperling.html (Accessed: February 9, 2005).

References

Adage.com. "Magazines by Circulation For 6 Months Ended 06/30/2004." *Adage.com*. http://www.adage.com/page.cms?pageId=604 (Accessed: January 14, 2005).

Adler, Moshe. "Stardom and Talent." In Victor Ginsburgh and David Throsby, Editors. *Handbook of Economics of Art and Culture*. Amsterdam: NorthHolland Publishing Co., 2005. http://www.columbia.edu/~ma820/economics%20of%20superstardom.htm (Accessed: December 22, 2004).

Albarran, Alan B. and Mierzejewska, Bozena I. "Media Concentration in the U. S. and European Union: A Comparative Analysis." *Sixth World Media Economics Conference*. Montréal, CanadaMay 12-15, 2004. www.cem.ulaval.ca/6thwmec/albarran_mierzejewska.pdf (Accessed: December 20, 2004).

Alberro, Alexander. *Conceptual Art and the Politics of Publicity*. Cambridge, MA: The MIT Press, 2004. http://mitpress.mit.edu/books/chapters/0262511843chap1.pdf (Accessed: January 31, 2005).

Alper, Neil and Wassall, Gregory. "Artists' Careers and Their Labor Markets." *European Center for Advanced Research in Economics and Statistics Conference on the Economics of Art and Culture*, Princeton University, September 10 - 12, 2004. http://www.ecare.ulb.ac.be/ecare/Princeton/papers/13alper.pdf (Accessed: December 22, 2004).

Alpers, Svetlana "Indelibly Etched: Svetlana Alpers on "Rembrandt's Journey." *ArtForum*. September, 2003 . http://www.findarticles.com/p/articles/mi_m0268/is_1_42/ai_108691762 (Accessed: December 10, 2004).

Americans for the Arts. *Arts & Economic Prosperity: The Economic Impact of Nonprofit Arts Organizations and Their Audiences.* Washington, DC: 2003. http://ww3.artsusa.org/information_resources/economic_impact/ (Accessed: January 14, 2005).

Anderson, Chris. "Recommendations Rule!" *The Long Tail: A public diary on the way to a book,* December 30, 2004. http://longtail.typepad.com/the_long_tail/2004/12/recommendations.html (Accessed: January 22, 2005).

Anderson, Chris. "The Long Tail." *Wired Magazine,* Vol. 12, No. 10, October 2004. http://www.wired.com/wired/archive/12.10/tail.html (Accessed: December 13, 2004).

Andrew Hudgins. "Piss Christ: Andres Serrano, 1987 (poem)." *Slate.com,* April 19, 2000. http://slate.msn.com/id/74144 (Accessed: February 7, 2005).

Art Museum of Missoula. "Miriam in Montana." From *Miriam Schapiro: Works on Paper: A Thirty Year Retrospective 1999.* Missoula, MT: November 17, 2004. http://artmissoula.org/exhibits/Shapiro/Shapiro3.html (Accessed: December 16, 2004).

Art Publishers Associations. "Fine Art Limited Editions Print Disclosure Laws." nd. http://apa.pmai.org/readall/printlaw.html (Accessed: January 5, 2005).

Artfacts.net. "100 Artist Ranking." *Artfacts.net,* January 9, 2005. http://www.artfacts.net/ranking/Page2_EN.php (Accessed: January 9, 2005).

ARTnews. "About *ARTnews.*" http://www.artnewsonline.com/advertise.cfm (Accessed: January 14, 2005).

Artprice.com. "Art Auction Data Bank: Auction Prices." Excerpt from *Art Martket Trends 2003.* Paris, 2004a. http://artdatabank.com/ (Accessed: December 21, 2004).

Artprice.com. "For budgets of less than EUR1,000, prints bring greater gains than paintings!" *Art Market Insight,* Jul 2002. http://web.artprice.com/ami/ami.aspx?id=NDg5MDE4ODExMTQ5OTk= (Accessed: December 21, 2004).

Artprice.com. *Art Martket Trends 2003*. Paris, 2004b. http://web.artprice.com/ami/ami.aspx?id=MDI4Nzg0NTE4NDU5OTk=&l=en (Accessed: December 10, 2004).

Axsom, Richard H. "Contemporary Art." In Claude J. Summers, Editor. *glbtq: An Encyclopedia of Gay, Lesbian, Bisexual, Transgender, and Queer Culture*. Chicago, IL: glbtq, 2002 (Last Updated February 7, 2004). www.glbtq.com/arts/contemp_art.html (Accessed: December 17, 2004).

Bagdikian, Ben H. *The Media Monopoly, Sixth Edition*. Boston, MA: Beacon Press, 2000,

Baker, David Weil. "Topical utopias: radicalizing humanism in Sixteenth-Century England." *Studies in English Literature, 1500-1900*, Vol. 36, 1996. http://gracewood0.tripod.com/bakermore.html (Accessed: February 1, 2005).

Barthes, Roland. *Camera Lucida: Reflections on Photography*. Trans. R. Howard. London: Harper and Collins, 1984.

Baudrillard, Jean. *Simulacra and Simulation*. Trans. Sheila Faria Glaser. Ann Arbor: U of Michigan P, 1994.

Bauer, Elise. "Online Art Sales." *On the Job*, December 05, 2003. http://www.elise.com/web/a/online_art_sales.php (Accessed: January 26, 2005).

Baumol, William J. and Bowen, William G. "On the Performing Arts: The Anatomy of their Economic Problems." *The American Economic Review*, Vol. 55, No 2, 1965, pp. 495-502.

Baumol, William J. and Bowen, William G. "The Mass Media and the Cost Disease." In Ruth Towse, editor. *Baumol's Cost Disease: The Arts and Other Victims*. Aldershot, UL: Edward Elgar, 1997.

Benjamin, Walter. "The Work of Art in the Age of Mechanical Reproduction" (1935). Excerpted in Charles Harrison and Paul Woods, editors. *Art in Theory 1900-1990: An Anthology of Changing Ideas*. Malden, MA: Blackwell Publishers, 1992, pp. 514-515. Full Text at http://web.bentley.edu/empl/c/rcrooks/toolbox/common_knowledge/general_communication/benjamin.html (Accessed: December 10, 2004).

Besharov, Gregory. "The Outbreak of the Cost Disease: Baumol and Bowen's Case for Public Support of the Arts." *Duke Economics Working Paper*, No. 03-06, October 2, 2003.

http://www.econ.duke.edu/~besharov/baumol_bowen.pdf (Accessed: February 8, 2005).

Beuys, Joseph. 1985. In Regina Brenner. "Political Activism." Minneapolis, MN: Walker Art Center, nd. http://www.walkerart.org/beuys/info_introframe.html (Accessed: February 9, 2005).

Beuys, Joseph. "Questions To Joseph Beuys: 1970 interview with Jörg Schellman and Bernd Klüser." in *Joseph Beuys: The Multiples*. Cambridge/Minneapolis/Munich/New York: Harvard University Art Museums, Walker Art Center, and Edition Schellmann, 1997. http://www.walkerart.org/beuys/info_introframe.html (Accessed: December 10, 2004).

Blessing, Jennifer et al. *Rrose is a Rrose is a Rrose: Gender Performance in Photography*. New York, NY: Guggenheim Museum Publications, 1997. http://shop.store.yahoo.com/guggenheim/rrosisrrosis.html (Accessed: December 17, 2004).

Booth, Eric. "Teaching Artistry: Building a Profession." *Keynote Address to the New Jersey Arts Education Collective*. Hamilton, NJ: Grounds for Sculpture, January 21, 2005. Also found in "Making Worlds and Making Them Better." Chicago, IL: Creative America, January 2005. http://www.tresser.com/Booth.htm (Accessed: January 26, 2005).

Bourdieu, Pierre. "The production of belief: Contribution to an economy of symbolic goods." *Media, Culture, and Society*, No. 2, pp. 261-293, 1980.

Bourdieu, Pierre. *Distinction: A Social Critique of the Judgement of Taste*. Richard Nice, Translator. Cambridge, MA: Harvard University Press, 1984.

Boxer, Sarah. "Chomp if You Like Art; Pac-Man Meets Mondrian's 'Broadway Boogie Woogie'." *The New York Times*, December 27, 2004. http://query.nytimes.com/search/restricted/article?res=F60F12FA34540C7 48EDDAB0994DC404482 (Accessed: January 31, 2005).

Boyle, James. "A Politics of Intellectual Property: Environmentalism For the Net?" Unpublished paper, 1997. http://www.law.duke.edu/boylesite/intprop.htm (Accessed: January 30, 2005).

Boyle, James. "The Second Enclosure Movement and the Construction of the Public Domain." *Law & Contemporary Problems.* Vol. 66, No. 33, Winter/Spring 2003.
http://www.law.duke.edu/pd/papers/boyle.pdf (Accessed: February 1, 2005).

Boynton, Robert. "Righting Copyright: Fair Use and "Digital Environmentalism." *Bookforum*, February March 2005.
http://www.bookforum.com/boynton.html (Accessed: January 30, 2005).

Brown, Anna M. "Foucauldian Perspectives on Midwifery Practices and Education." *The Internet Journal of Advanced Nursing Practice.*, Vol. 6, No. 1, 2003.
http://www.ispub.com/ostia/index.php?xmlFilePath=journals/ijanp/vol6n1/midwifes.xml (Accessed: December 17, 2004).

Brown, Janelle. "Ticky-tacky houses from "The Painter of Light™." *Salon.com*, March 18, 2002.
http://www.salon.com/mwt/style/2002/03/18/kinkade_village/index.html (Accessed: December 22, 2004).

Buck, Louisa. *Market Matters: The Dynamics of the Contemporary Art Market.* London, UK: Arts Council of England, 2004.
http://www.artscouncil.org.uk/documents/publications/phpbWxMrb.pdf (Accessed: January 20, 2005).

Bureau of Labor Statistics, U.S. Department of Labor. *Current Population Survey*, 2001. www.bls.gov/cps/cpsa2001.pdf (Accessed: December 20, 2004).

Bureau of Labor Statistics, U.S. Department of Labor. *Occupational Outlook Handbook, 2004-05 Edition, Designers.*
http://www.bls.gov/oco/ocos090.htm (Accessed: December 20, 2004).

CAP Ventures, *Large Format Digital Fine Art Market Study.* Norwell, MA: CAP Ventures, Inc., January 2004.
http://www.capv.com/eprise/main/Store/pdf/DigitalFineArt.pdf (Accessed: December 10, 2004).

Capps, Kriston. "Significant Growth in Creepy Installations Predicted for 2005." *Grammar Police*, December 15, 2004.
http://grammarpolice.net/archives/000458.php (Accessed: February 1, 2005).

Carr, David. "A Survivor at Condé Nast Chooses to Bow Out." *The New York Times*, January 6, 2005, p. C1. http://query.nytimes.com/gst/abstract.html?res=F50B1EFB3B5D0C758CD DA80894DD404482&incamp=archive:search (Accessed: January 17, 2005).

Carr, David. "Art Magazine Aims to Turn Consumers into Connoisseurs." *The New York Times*, August 5, 2004, p. E1. http://query.nytimes.com/gst/abstract.html?res=F40713F63F580C768CDD A10894DC404482&incamp=archive:search (Accessed: January 17, 2005).

Carter, Thomas F. *Invention of Printing in China and its Spread Westward*. New York, NY: Columbia University Press: 1925. Cited in Lawrence Lessig. *The Lessig Blog*, June 3, 2003. http://www.lessig.org/blog/archives/001256.shtml (Accessed: December 10, 2004).

Chaker, Anne Marie. "When art imitates art: the 'giclee' debate." *The Wall Street Journal*, July 21, 2004. http://online.wsj.com/article/0,,SB109036461735169144,00.html (Accessed: December 10, 2004).

Chartrand, Harry Hillman. "The American arts industry: size and significance." Washington, DC: National Endowment for the Arts, 1992. www.eric.ed.gov.

Chatman, Delle. "The Artist as Politician." *Newtopia Magazine*, January 2005. http://www.newtopiamagazine.net/content/issue20/oped/artists.php (Accessed: February 3, 2005).

Coleman, Caryn, et al. "Ever-Glades." *Art Blogging LA*, December 16, 2004. http://art.blogging.la/archives/002103.phtml (Accessed: February 1, 2005).

Corber, Robert J. and Valocchi, Stephen, editors. *Queer Studies: an Interdisciplinary Reader*. Malden, MA: Blackwell Publishing Ltd., 2003.

Cornwell, Tim. "Expert rebuffs Hockney claim that Old Masters traced their paintings." *The Scotsman*, January 13 2005. http://news.scotsman.com/arts.cfm?id=42992005

Cowen, Tyler and Tabarook, Alexander. "An Economic Theory of Avant-Garde and Popular Art, or High and Low Culture." *Southern Economic Journal*, Vol. 67, No. 2, pp. 232-253.

http://www.gmu.edu/jbc/Tyler/high-and-low-culture.PDF (Accessed: December 21, 2004).

Cowen, Tyler. *In Praise of Commercial Culture*. Cambridge, MA: Harvard University Press, 1998. http://www.gmu.edu/jbc/Tyler/Chapter1.htm (Accessed: February 8, 2005).

Cray, Dan. "Art of Selling Kitsch." *Time Magazine*, August 30, 1999, p. 62. http://www.time.com/time/archive/preview/0,10987,1101990830-29788,00.html (Accessed: May 8, 2003).

Critical Art Ensemble. *Digital Resistance*. Brooklyn, NY: Autonomedia, nd. http://www.critical-art.net/books/index.html (Accessed December 10, 2004).

Curry, Adam. "Ipodder for Advocacy." *Network-Centric Advocacy*, September 21, 2004. http://www.network-centricadvocacy.net/2004/09/ipodder_for_adv.html (Accessed: January 28, 2005).

Danto, Arthur C. *After the End of Art: Contemporary Art and the Pale of History*. Princeton, NJ: Princeton University Press, 1997.

Davis, Nicole. "Interview with John Baldessari." *Artnet.com*, December 7, 2004. http://artnet.com/Magazine/features/davis/davis12-7-04.asp (Accessed: December 11, 2004).

Deleuze, Gilles. *Difference and Repetition*. Trans. Paul Patton. New York, NY: Columbia University Press, 1994.

Derrida, Jacques. *The Truth in Painting*. Trans. Geoff Bennington and Ian McLeod. Chicago, IL: University of Chicago Press, 1987.

Dery, Marc. "Culture Jamming: Hacking, Slashing and Sniping in the Empire of Signs." *Open Magazine*, No. 25, 1993. http://www.rebelart.net/source/dery.pdf (Accessed: January 22, 2005).

Dewan, Shaila. "Study in Green: People love Thomas Kinkade, the Painter of Light. Is that a problem?" *Houston Press*, May 27, 1999. http://www.houstonpress.com/issues/1999-05-27/culture/art2.html (Accessed: January 8, 2005).

Dietz, Steve. "Why Have There Been no Great Net Artists?" San Jose, CA: CADRE Laboratory for New Media, November 30, 1999. http://www.afsnitp.dk/onoff/Texts/dietzwhyhavether.html (Accessed: January 26, 2005).

Elkins, James. "From Original to Copy and Back Again." *Interdisciplines*. November 22, 2004. [Reprinted from James Elkins. "From Copy to Forgery and Back Again," *The British Journal of Aesthetics*, Vol. 33, No. 2, 1993, pp. 113-20.] http://www.interdisciplines.org/artcognition/papers/6 (Accessed: December 20, 2004).

Enterprise North East. "Prints Charming." *icTeesside*, September 1 2004. http://icteesside.icnetwork.co.uk/0400business/enterprise/entrepreneurs/tm_objectid=14698365&method=full&siteid=50081&headline=prints-charming-name_page.html (Accessed: January 22, 2005).

Felluga, Dino. "The Dürer Woodcut: Postmodernism." *Introductory Guide to Critical Theory*. Purdue University, November 28, 2003. http://www.purdue.edu/guidetotheory/postmodernism/image/ (Accessed: February 10, 2005).

Fineman, Mia. "The Biennial That's Not at the Biennial." *The New York Times*, May 2, 2004, p. 48. http://query.nytimes.com/gst/abstract.html?res=F20910FA345E0C718CDDAC0894DC404482 (Accessed: January 7, 2005).

Florida, Richard. *The Rise of the Creative Class: And How it's Transforming Work, Leisure, Community and Everyday Life*. New York, NY: Basic Books, 2002.

Forstenzer, Martin. "In Search of Fine Art Amid the Paper Towels." *The New York Times*, February 22, 2004, p C4. http://query.nytimes.com/gst/abstract.html?res=F50C16FD35590C718EDDAB0894DC404482&incamp=archive:search (Accessed: March 2, 2004).

Franck, Georg. *Okonomie der Aufmerksamkeit*. Munich: Carl Hanser Verlag, 1998.

Frank, Robert H. "How not to Buy Happiness." *Daedulus*, Spring 2004. http://mitpress.mit.edu/journals/pdf/daed_133_2_69_0.pdf (Accessed: February 4, 2005).

Frank, Robert H. and Cook, Philip J. *The Winner-Take-All Society*. New York, NY: The Free Press, 1995

Frost, Randall. "Staying Power: Surviving the Limelight." *Brandchannel.com*, June 21, 2004.

http://www.interbrand.com.sg/print_page.asp?ar_id=215§ion=main (Accessed: December 10, 2004).

Fullerton, Don. "Tax Policy Toward Art Museums." In Martin Feldstein, editor. *The Economics of Art Museums*. Chicago, IL: University of Chicago Press, 1991, pp. 195-235.

Galenson, David W. "The Reappearing Masterpiece: Ranking American Artists and Art Works of the Late Twentieth Century." Chicago, IL: University of Chicago, July 2003. http://www.patenting-art.com/economic/galenson.htm (Accessed: December 21, 2004).

Galligan, Ann M. and Cherbo, Joni Maya. "Financial Support for Individual Artists in the United States." Montréal, Canada: Third International Conference on Cultural Policy Research, August 25-28, 2004. http://www.hec.ca/iccpr/PDF_Texts/GalliganA_CherboJ.pdf (Accessed: January 30, 2005).

Ganis, William V. "Digital Sculpture: Ars Ex Machina." *Sculpture*, Vol. 23 No. 8, October 2004. http://www.sculpture.org/documents/scmag04/sept04/rapidproto/sept04_rapidproto.htm (Accessed: January 7, 2005).

Gans, Herbert J. *Popular Culture and High Culture: An Analysis and Evaluation of Taste*. New York, NY: Basic Books, 1999.

Garcia, David and Lovink, Geert. "The DEF of Tactical Media." [or part two of the ABC of Tactical Media, posted to nettime in the spring of 1997]. http://amsterdam.nettime.org/Lists-Archives/nettime-l-9902/msg00104.html (Accessed: January 31, 2005).

Gazzara, Ben. "In the Moment: My Life as an Actor." On *The Leonard Lopate Show WNYC AM 820*, November 23, 2004. http://www.wnyc.com/shows/lopate/archive.html?month=200411 (Accessed: December 10, 2004).

Gibson, Todd. "The Thomas Kinkade Company Acquires Maurizio Cattelan." From the Floor, December 15, 2004. http://fromthefloor.blogspot.com/2004/12/thomas-kinkade-company-acquires.html (Accessed: February 1, 2005).

Gilbert, David A. "NYC Art Mobs Launches on Dec. 8!" *Smart Mobs*, December 07, 2004. http://www.smartmobs.com/archive/2004/12/07/nyc_art_mobs_la.html (Accessed: January 18, 2005).

Gladwell, Malcolm. *The Tipping Point: How Little Things Can Make a Big Difference*. New York, NY: Little, Brown, 2000. http://www.gladwell.com/tippingpoint/index.html (Accessed: January 22, 2005).

Goddard, Stephen. "The Prairie Print Makers." Lawrence, KS: Spencer Museum of Art, University of Kansas, 1998. http://www.ku.edu/~sma/ppm/ppmintro.htm (Accessed: December 10, 2004).

Goetz, Thomas. "Sample the Future." *Wired Magazine*, No. 12.11, November 2004. http://www.wired.com/wired/archive/12.11/sample.html (Accessed: January 26, 2005).

Goldman, Ben. "Community Right to Know: Environmental Information for Citizen Participation." *Environmental Impact Assessment Review*, Vol. 12, 1992, pp. 315-325.

Goldman, Ben. "Still Starving: the Difficult Labor Market for Visual Artists." *Journal of Labor and Society*, forthcoming 2005.

Gomez, Edward. "Asian Pop: How Hello Kitty Came to Rule the World." *San Francisco Chronicle*, July 14, 2004. http://sfgate.com/cgi-bin/article.cgi?f=/g/a/2004/07/14/helkit.DTL (Accessed: January 22, 2005).

Gordon Blankinship, Donna. "Orlando dealer offers Picasso original on Costco Web site." *The Miami Herald*, January 18, 2005. http://www.miami.com/mld/miamiherald/news/breaking_news/10676228.htm (Accessed: January 21, 2005).

Gouma-Peterson, Thalia & Matthews, Patricia: The feminist critique of art history. *Art Bulletin*, Vol. 69, No. 3, 1987, pp. 326-357. http://www.opiskelijakirjasto.lib.helsinki.fi/eres/hum/art/L01a.pdf (Accessed: December 16, 2004).

Graham, Jefferson. "Start-ups turn flat-panel TVs into works of art." *USA Today*, March 15, 2004. http://www.galleryplayer.com/press_startupsturn.aspx (Accessed: January 7, 2005).

Grantmakers in the Arts. "A snapshot: foundation grants to arts and culture, 1999." *GIA Reader*, Vol. 12, No. 3, 2001. http://www.giarts.org/pdf/snapshot.pdf (Accessed: January 14, 2005).

Graphic Artists Guild. *Graphic Artists Guild Handbook: Pricing and Ethical Guidelines*. New York, NY: Graphic Artists Guild, 2003.

Graphic Design USA. "Lookout." *Graphic Design USA*, May, 2001. http://www.gdusa.com/lookout/5_01.php (Accessed: December 10, 2004).

Graybow, Martha. "Gates' Corbis sees turning cash flow positive." *Reuters*, January 19, 2005. http://www.reuters.com/financeQuoteCompanyNewsArticle.jhtml?duid=MTFH90952_2005-01-19_19-32-18_N19662902_NEWSML (Accessed: February 4, 2005).

Greene, Rachel. *Internet Art*. London, UK: Thames & Hudson, 2004.

Grether, Reinhold. "Mob Art Links." *Netzwissenschaft*. http://www.netzwissenschaft.de/mob.htm (Accessed: January 31, 2005).

Group, Thetis M. and Roberts, Joan I. *Nursing, Physician Control, and the Medical Monopoly. Historical Perspectives on Gendered Inequality in Roles, Rights, and Range of Practice*. Bloomington, IN: Indiana University Press, 2001. http://www.indiana.edu/~iupress/books/0-253-33926-e.shtml (Accessed: December 17, 2004).

Harris, Michael D. *Colored Pictures: Race and Visual Representation*. Chapel Hill, NC: University of North Carolina Press, 2003.

Hays, Constance L. "As Martha Stewart Does Time, Flush Times for Her Company." *The New York Times*, January 20, 2005. http://www.nytimes.com/2005/01/20/business/20martha.html (Accessed: January 22, 2005).

Heilbrun, James & Gray, Charles M. *The Economics of Art and Culture: Second Edition*. New York, NY: Cambridge University Press, 2001.

Hickey, Dave. "Letters: Say hello to Rodney." London Review of Books, Vol. 22 No. 7, March 30, 2000. http://www.lrb.co.uk/v22/n07/letters.html (Accessed: February 1, 2005).

Hickey, Dave. *Air Guitar: Essays in Art and Democracy*. Los Angeles, CA: Art Issues Press, 1997.

Hickey, Dave. *The Invisible Dragon: Four Essays on Beauty*. Los Angeles, CA: Art Issues Press, 1993.

Higgens, Charlotte. "Work of art that inspired a movement....a urinal." *The Guardian*, December 2, 2004. http://www.guardian.co.uk/uk_news/story/0,3604,1364095,00.html (Accessed: December 10, 2004).

Hirshberg, Peter. "Scratch Code." November 17, 2004. http://atomicbomb.typepad.com/peter_hirshbergs_weblog_o/2004/11/scratch_code_1.html (Accessed: January 18, 2005).

Hislop's Art Sales Index. "Contemporary Art Auction Sales." Surrey, UK: Art Sales Index Ltd., 2005a. http://www.art-sales-index.com/pages/Graphs___Charts/contemporary.html (Accessed: January 14, 2005).

Hislop's Art Sales Index. "USA Art Auction Market (12/24)." Surrey, UK: Art Sales Index Ltd., 2005b. http://www.art-sales-index.com/pages/Graphs___Charts/uk___usa.html (Accessed: January 14, 2005).

Hobsbawm, Eric. *Behind the Times: The Decline and Fall of the 20th-Century Avant-Gardes*. London, UK: Thames and Hudson, 1998.

Hobsbawm, Eric. *The Age of Extremes: A History of the World, 1914-1991*. New York, NY: Vintage Press, 1996.

Hockney, David. *Secret Knowledge: Rediscovering the Lost Techniques of the Old Masters*. New York, NY: Penguin Group, 2001.

Holbert, R. Mac. "The State of the Art." *White Paper*: San Jose, CA: Adobe Systems, 2004. http://www.adobe.com/digitalimag/pdfs/state_of_art.pdf (Accessed: December 10, 2004).

Home Accents Today and George Little Management. "2000 Universe Study." *Home Accents Today*, December 2000. http://www.homeaccentstoday.com/Universe2000.asp (Accessed: December 10, 2004).

hooks, bell. *Art on My Mind: Visual Politics*. New York, NY: The New Press, 1995.

Horyn, Cathy. "A Store Made for Right Now: You Shop Until It's Dropped." *The New York Times*, February 17, 2004, p. 1. http://query.nytimes.com/gst/abstract.html?res=F30C10FC3F590C748DDDAB0894DC404482 (Accessed February 18, 2004).

Howe, Jeff. "The Two Faces of Takashi Murakami." *Wired Magazine*, No. 11.11, November 2003. http://www.wired.com/wired/archive/11.11/artist.html (Accessed: January 28, 2005).

Howkins, John. *The Creative Economy: How People Make Money from Ideas*. New York, NY: Penguin Press, 2001.

Humphries, Stephen. "'Podcast' your world: Digital technology for iPod does for radio what blogs did for the Internet." *The Christian Science Monitor*, December 10, 2004. http://www.csmonitor.com/2004/1210/p12s03-stct.html (Accessed: February 4, 2005).

Hunter, Dan and Lastowka, F. Gregory. "Amateur-to-Amateur." *William & Mary Law Review*, Vol. 46, December 2004. http://papers.ssrn.com/sol3/papers.cfm?abstract_id=601808 (Accessed: January 22, 2005).

IT Strategies. "I.T. Sees Digital Fine Art Becoming a $740 Million Market." *The Big Picture*, April 18, 2002. http://bigpicture.net/index.php3?openchan=yes&channelnum=6&content=936&displaynow=yes (Accessed: December 10, 2004).

Jackson, Maria-Rosiario, et al. *Investing in Creativity: A Study of the Support Structure for U.S. Artists*. Washington, DC: Urban Institute, 2003. www.usartistsreport.org (Accessed: December 20, 2004).

Jacobs, Leonard. "Cameron Revisits 'Cultural Citizenship' As Bush II Begins." *Backstage*, February 03, 2005. http://www.backstage.com/backstage/features/article_display.jsp?vnu_content_id=1000788849 (Accessed: February 4, 2005).

James, Anna. "Prophets in the west's secular temples." *Financial Times*, January 17 2005. http://news.ft.com/cms/s/f74e5cca-682c-11d9-a11e-00000e2511c8.html (Accessed: January 18, 2005).

Jameson, Fredric. *Postmodernism, or, the Cultural Logic of Late Capitalism*. Durham, NC: Duke University Press, 1991. Partial excerpt at http://www.eng.fju.edu.tw/Literary_Criticism/postmodernism/jameson_text_complete.htm (Accessed December 10, 2004).

Jensen, Brooks. "What Size is the Edition?" *Lenswork Magazine*, No. 36, July-August 2001. http://www.lenswork.com/whatsizeistheedition.pdf (Accessed: December 21, 2004).

Johnson, Harald. *Mastering Digital Printing*. Cincinnati, OH: Muska & Lipman, 2005. http://www.dpandi.com/giclee/giclee.html (Accessed: December 10, 2004).

Kallir, Jane. "A Brief History of The ADAA." New York, NY: Art Dealers Association of America, nd. http://www.artdealers.org/who.history.html (Accessed: February 8, 2005).

Kammen, Michael. *American Culture, American Tastes: Social Change and the Twentieth Century*. New York, NY: Basic Books, 2000.

Keating, Anne B. with Hargitai, Joseph. *The Wired Professor: A Guide to Incorporating the World Wide Web in College Instruction*. New York, NY: New York University Press, 1999. http://nyupress.org/professor/webinteaching/ (Accessed: December 10, 2004).

Keller, Julia. "The Great DIVIDE: Is the public stupid? Are critics snobs? What drives the split between what's popular and what critics praise?" *Chicago Tribune*, January 25, 2004, p. 1. http://pqasb.pqarchiver.com/chicagotribune/index.html?ts=1105222551 (Accessed: January 26, 2004).

Kieran, Matthew. *Revealing Art*. London, UK: Routledge, 2004.

Kimmelman, Michael. "For a Cinderella Art, a Fairy Godmother." *The New York Times*, January 7, 2005, p. E39. http://www.nytimes.com/2005/01/07/arts/design/07kimm.html?oref=login (Accessed: January 7, 2005).

Kreidler, John. "Leverage Lost: The Nonprofit Arts in the Post-Ford Era." *In Motion Magazine*, February 16, 1996. http://inmotionmagazine.com/lost.html (Accessed: January 14, 2005).

Krugman, Paul. *Peddling Prosperity: Economic Sense and Nonsense in an Age of Diminished Expectations*. New York, NY: W. W. Norton & Company, 1995.

Kuoni, Carin. *Joseph Beuys in America: Energy Plan for the Western Man*. New York, NY: Four Walls Eight Windows, 1993.

Kurlantzick, Joshua. "A New Forum (Blogging) Inspires the Old (Books)." *The New York Times*, December 15, 2004, p E1. http://query.nytimes.com/gst/abstract.html?res=F00B17FF3C540C768DDDAB0994DC404482&incamp=archive:search (Accessed: December 15, 2004).

Kusin & Co. *The European Art Market in 2002: A Survey*. Helvoirt, The Netherlands: The European Fine Art Foundation, 2002.

http://www.kusin.com/publications_2.htm (Accessed: December 10, 2004).

Lazarus, David. "Storm cloud over Kinkade. *San Francisco Chronicle*, April 7, 2002. http://www.sfgate.com/cgi-bin/article.cgi?file=/chronicle/archive/2002/04/07/BU150023.DTL&type=business (Accessed: December 22, 2004).

Leibowitz, Stan and Margolis, Stephen E. "Policy and Path Dependence: From QWERTY to Windows 95." *Regulation*, Vol. 18, No. 3, 1995. http://www.cato.org/pubs/regulation/reg18n3d.html (Accessed: December 20, 2004).

Levine, Lawrence W. *Highbrow/Lowbrow: The Emergence of Cultural Hierarchy in America*. Cambridge, MA: Harvard University Press, 1988.

Levine, Sherrie. *Style Magazine*, March 1982. Excerpted in Charles Harrison and Paul Woods, editors. *Art in Theory 1900-1990: An Anthology of Changing Ideas*. Malden, MA: Blackwell Publishers, 1992, p. 1067.

License! "Industry Annual Report." *License!* October 1, 2004. http://www.licensemag.com/licensemag/article/articleDetail.jsp?id=127352 (Accessed: December 10, 2004).

Licensing Industry Merchandisers' Association. *Harvard/Yale Royalty Revenue Study*. New York, NY: LIMA, June 8, 2004. http://www.licensing.org/news/PressRelease/LIMAStatisticalStudy04.doc (Accessed: December 10, 2004).

Lowell, Julia. *State Arts Agencies 1965-2003: Whose Interests to Serve?* Santa Monica, CA: RAND Corporation, 2004. http://www.rand.org/pubs/monographs/2004/RAND_MG121.pdf (Accessed: January 31, 2005).

Lyotard, Jean-François. *The Postmodern Condition: A Report on Knowledge*. Manchester, UK: Manchester University Press, 1984. http://www.egs.edu/faculty/lyotard/lyotard-the-postmodern-condition.html (Accessed: January 14, 2005).

Madden, Mary. *Artists, Musicians and the Internet*. Washington, DC: Pew Internet and American Life Project, December 5, 2004. http://www.pewinternet.org/pdfs/PIP_Artists.Musicians_Report.pdf (Accessed: December 10, 2004).

Masters, Greg. "Joseph Beuys: Past the Affable." *Artchive.com*, 1999. http://www.artchive.com/artchive/B/beuys.html (Accessed: January 29, 2005).

Matheson, Victor A. and Baade, Robert A." 'Death-Effect' on Collectible Prices." *Applied Economics*, June 20, 2004, vol. 36, no. 11, pp. 1151-1155. http://www.williams.edu/Economics/wp/mathesonmemorabilia.pdf (Accessed: December 21, 2004).

McLuhan, Marshall et al. *Essential McLuhan*. New York, NY: Basic Books, 1996.

Media Arts Group. *Form 10-K: Annual Report*. Washington, DC: Securities and Exchange Commission, 2003. http://www.sec.gov/Archives/edgar/data/924645/000104746903010935/0001047469-03-010935-index.htm (Accessed: January 7, 2005).

Media Arts Group. *Form 10-K: Annual Report*. Washington, DC: Securities and Exchange Commission, 2000. http://www.sec.gov/Archives/edgar/data/924645/000091205700030409/0000912057-00-030409-index.htm (Accessed: January 7, 2005).

Media Arts Group. *Form 10-K: Annual Report*. Washington, DC: Securities and Exchange Commission, 1997. http://www.sec.gov/Archives/edgar/data/924645/0000891618-97-002732.txt (Accessed: January 7, 2005).

Menkes, Suzy. "Managing style success." *The International Herald Tribune*. September 28, 2004. http://www.iht.com/bin/print.php?file=540733.html (Accessed: December 10, 2004).

Middlebrooks, Kaley. "New Media Art: A New Frontier or Continued Tradition?" *Good Work Project Report Series, No. 9*. Cambridge, MA: Harvard University, January, 2001. http://pzweb.harvard.edu/eBookstore/PDFs/GoodWork9.pdf (Accessed: February 4, 2005).

Miller, Laura. "The Writer of Dreck™." *Salon.com*, March 18, 2002. http://www.salon.com/books/feature/2002/03/18/light/index.html?x (Accessed: December 22, 2004).

Mirapaul, Matthew. "Online Gallery Is on the Block: Visitors Came, but Didn't Buy." *The New York Times*, May 20, 2002.

http://query.nytimes.com/search/restricted/article?res=F40714F63F5C0C738EDDAC0894DA404482 (Accessed: January 20, 2005).

Morrison, William G. "Economics and Economic Perceptions of the Art Market." *Art Business Magazine,* June 17, 1996. http://collection.nlc-bnc.ca/100/202/300/artbus/1996/artbus.b02/banktwentyone.html (Accessed: February 8, 2005).

Mutch, Kevin. "Pod Theory." New York, NY: PODpublishing @ Sumo Graphics, nd. http://podgallery.com/html/theory.html (Accessed: December 22, 2004).

National Association of State Art Agencies. "State Arts Agency Funding Reflects Continuing State Budget Woes." Washington, DC: National Association of State Art Agencies, July 2004. www.nasaa-arts.org/publications/legapp.shtml (Accessed: January 14, 2005).

National Center for Education Statistics. *Digest of Education Statistics, 2001.* Washington, DC: U.S. Department of Education, 2001. http://nces.ed.gov/pubs2002/digest2001/tables/PDF/table258.pdf (Accessed: January 14, 2005).

National Endowment for the Arts. "National Endowment for the Arts Appropriations History." Washington, DC: National Endowment for the Arts, nd. http://www.arts.gov/about/Facts/AppropriationsHistory.html (Accessed: January 14, 2005).

National Endowment for the Arts. "International data on government spending on the arts, Note #74." Washington, DC: National Endowment for the Arts, 2000. http://www.arts.gov/pub/Notes/74.pdf (Accessed: January 14, 2005).

National Endowment for the Arts. *2002 Survey of Public Participation in the Arts: Research Division Report #45.* Washington, DC: National Endowment for the Arts, 2004. http://www.arts.gov/pub/NEASurvey2004.pdf (Accessed: December 10, 2004).

National Endowment for the Arts. *How the United States Funds the Arts.* Washington, DC: National Endowment for the Arts, October 2004. http://www.arts.gov/pub/how.pdf (Accessed: January 14, 2005).

Netimperative. "Britart websites come together in merger." London, UK: e-consultancy, May 19, 2003. http://www.e-

consultancy.com/newsfeatures/151105/britart-websites-come-together-in-merger.html (Accessed: March 31, 2005).

Neumeier, Marty. *The Branding Gap: How to Bridge the Distance between Business Strategy and Design*. Berkeley, CA: New Riders, 2003.

Nextmonet.com. http://www.nextmonet.com/index.php (Accessed: January 29, 2005).

Nichols, Bonnie. "Artist Employment in 2003, Note #87." Washington, DC: National Endowment for the Arts, 2004. http://www.nea.gov/pub/Notes/87.pdf (Accessed: December 20, 2004).

Nokia. "Connect to Art!" Press Release, November 02, 2004. http://press.nokia.com/PR/200411/966983_5.html (Accessed: January 30, 2005).

O'Doherty, Brian. "Inside the White Cube: Notes on the Gallery Space." *Artforum*, No. 14, March 1976, p. 24. Reprinted as *Inside the White Cube: The Ideology of the Gallery Space, Expanded Edition*. Berkeley, CA: University of California Press, 2000. http://www.societyofcontrol.com/whitecube/insidewc.htm (Accessed: January 29, 2005).

Oliver, Brooke. "Expanding Art Markets: Prints, Certificates of Authenticity, and Art Licensing." Santa Fe, NM: CLE International Visual Arts & Law Conference, 2004. http://www.artemama.com/media/expndart_mkts_2004.pdf (Accessed: December 10, 2004).

Orenstein, Nadine M. "Rembrandt Harmensz van Rijn (1606-1669): Prints." In *Timeline of Art History*. New York, NY: Metropolitan Museum of Art, nd. http://www.metmuseum.org/toah/hd/rembp/hd_rembp.htm (Accessed: December 10, 2004).

Paglia, Camille. "The Magic of Images: Word and Picture in a Media Age." *Frontpage Magazine*, April 12, 2004. http://frontpagemag.com/Articles/ReadArticle.asp?ID=12923 (Accessed: December 16, 2004).

Papatola, Dominic P. "U.K. contrast shows pitiful state of arts funding." *Pioneer Press*, December 19, 2004. http://www.twincities.com/mld/twincities/news/columnists/10433620.htm (Accessed: January 22, 2005).

Paul, Christiane. *Digital Art*. London, UK: Thames & Hudson, 2003.

Philanthropic Research, Inc. *Guidestar: The National Database of Nonprofit Organizations*. http://www.guidestar.org/ (Accessed: December 20, 2004).

Platzker, David. "Reconsidering the Fine Art Print in the Age of Mechanical Reproduction." In David Platzker and Elizabeth Wyckoff. *Hard Pressed: 600 Years of Prints and Process*. New York, NY: Hudson Hills Press, 2000.

Polsky, Richard. "Art Market Guide 2003." *Artnet.com*, October 10, 2003. http://www.artnet.com/Magazine/features/polsky2/polsky10-10-03.asp (Accessed: January 28, 2005).

Porter, Eduardo. "Economists Have Advice for Potential Buyers as the Art Market Heats Up." *The New York Times*, December 1, 2004. http://query.nytimes.com/gst/abstract.html?res=F30611FA3A5A0C728CDDAB0994DC404482 (Accessed: December 1, 2004).

Postrel, Virginia. "With So Many Choices, No Wonder You Need Help." *The New York Times*, December 7, 2004. http://www.nytimes.com/2004/12/07/business/businessspecial/07POST.html?ex=1106542800&en=212f882eebf7fd9a&ei=5070&oref=login&ex=1104555600&en=b2ccb06bc5af88f8&ei=5070 (Accessed: January 22, 2005).

Pratt, Andy C. "Intellectual Property Rights in the Age of Digital Reproduction: Implications for the Arts." London, UK: Arts Council of England, April 6, 2001. http://www.lse.ac.uk/collections/geographyAndEnvironment/whosWho/profiles/pratt/pdf/IPRreport.pdf (Accessed: January 20, 2005).

PricewaterhouseCoopers. " PwC Outlook Forecasts Industry Gaining Momentum, Growing to $1.7 Trillion in 2008; Video Games and Internet Will Be Fastest-Growing Industry Segments." Press Release for *Global Entertainment and Media Outlook: 2004-2008*. New York, NY: PricewaterhouseCoopers, June 29, 2004. http://pwc.com/extweb/ncpressrelease.nsf/DocID/5F00EEB0CD947F6085256EC2005D6D19 (Accessed: February 4, 2005).

Princeton Survey Research Associates. "Public Perceptions About Artists: A Report of Survey Findings for the Nation and Nine Metropolitan Areas." Washington, DC: Urban Institute, September 2003.

http://www.usartistsreport.org/docs/pdf/Public_perceptions.pdf (Accessed: December 21, 2004).

Reardon, Christopher. "The Market & The Muse: If an Artist Paints in Monastic Seclusion, Is it Art?" *National Arts Journalism Program Articles No. 4: Art & Commerce*, 1999. http://www.najp.org/publications/articles/04/reardon.pdf (Accessed: December 10, 2004).

Richardson, Damone and Figueroa, Maria. "Consolidation and labor in the arts and entertainment: A peek at Clear Channel." *Journal of Labor and Society*, Vol. 8, No. 1, September 2004, pp. 83-97.

Rinder, Lawrence. "Bitstreams: Art in the Digital Age." New York, NY: Whitney Museum of American Art, 2001. http://www.whitney.org/bitstreams/pdf/rinder.pdf (Accessed: January 18, 2005).

Robinson, Walter. "The 2004 Revue." *Artnet Magazine*, December 30, 2004. http://artnet.com/Magazine/reviews/walrobinson/robinson12-30-04.asp (Accessed: January 7, 2005).

Rohr-Bongard, Linde. "Der Capital-Kunstkompass 2004: Perfektes Rüstzeug." *Capital*, October 28, 2004. http://www.capital.de/leb/art/259849.html and http://www.capital.de/leb/pdf/ranking.pdf (Accessed: January 9, 2005).

RollingStone.com. "Advertise with us." *RollingStone.com*. http://www.rollingstone.com/advertisewithus?pageid=rs.Home&pageregion=Footer (Accessed: January 14, 2005).

Rosen, Christine. "The Age of Egocasting," *The New Atlantis*, No. 7, Fall 2004/Winter 2005, pp. 51-72. http://www.thenewatlantis.com/archive/7/rosen.htm (Accessed: January 23, 2005).

Rosen, Sherwin. "The Economics of Superstars." *American Economic Review*, Vol. 71, 1981.

Ross, David A. *010101: Art in Technological Times*. San Francisco, CA: San Francisco Museum of Modern Art, 2001.

Ross, David. "Net.art in the Age of Digital Reproduction." Lecture at San Jose University March 2 1999. http://switch.sjsu.edu/web/ross.html (Accessed: December 10, 2004).

Røyseng, Sigrid, Mangset, Per and Borgen, Jorunn Spord. "Not Just A Few Are Called, But Everyone." *3rd International Conference on Cultural Policy Research*. Montreal, Canada, August, 2004. http://www.hec.ca/iccpr/PDF_Texts/Royseng_Mangset_Borgen.pdf (Accessed: December 19, 2004).

Rozhon, Tracie. "Luxury Market Thrives in Holiday Season." *The New York Times*, December 12, 2004 http://www.nytimes.com/2004/12/12/business/12luxury.html?oref=login (Accessed: February 4, 2005).

Rubenstein, Raphael. "Art in the Blogosphere." *Art in America*, January 2005. http://www.artinamericamagazine.com/images/Frontpage_12_28.pdf (Accessed: January 18, 2005).

Sacks, Steve, director/curator. "Scratch Code: A selection of historic computational works from 1950's - 1970's plotter drawings, photos, prints, sculptures, and film." New York, NY: Bitforms Gallery, November 12, 2004 - January 16, 2005. http://www.bitforms.com/scratchcode/ (Accessed: January 18, 2005).

Saltz, Jerry. "Feeding Frenzy: Disgusting? Depressing? Or are art fairs the triumph of the corporate avant-garde?" *The Vilage Voice*, January 28, 2005. http://www.villagevoice.com/art/0505,saltz,60614,13.html (Accessed: February 4, 2005).

Schwartz, Gary. *Rembrandt: His Life, His Paintings*. New York, NY: Penguin, 1991, p. 50.

Schwartz, Michael. *Rembrandt: Master Etchings and Comparative Views*. Beverly Hills, CA: Galerie Michael, 2004.

Sher, Robert. "I want a new picture." *APA Market Expansion Committee Report*. Jackson, MI: Art Publishers Association, September 19, 2000. http://apa.pmai.org/readall/atlanta2000/index.htm (Accessed: December 10, 2004).

Shuman, Michael H. and Fuller, Merrian. "Profits for Justice." *The Nation*, January 24, 2005. http://www.thenation.com/doc.mhtml?i=20050124&s=shuman (Accessed: January 24, 2005).

Siegel, Katy. "Takashi Murakami: Marianne Boesky - Reviews: New York." *ArtForum*, June 2003.

http://www.findarticles.com/p/articles/mi_m0268/is_10_41/ai_103989804 (Accessed: January 28, 2005).

Simmons, Russell. *Life and def: Sex, Drugs, Money, and God*. New York, NY: Crown Publishers, 2001.

Siwek, Stephen E. *Copyright Industries in the U.S. Economy*. Washington, DC: International Intellectual Property Alliance, 2004. http://www.iipa.com/pdf/2004_SIWEK_FULL.pdf (Accessed: December 10, 2004).

Southeastern Institute of Research. *Study of Consumer Purchases of Print Art Pictures*. Jackson, MI: Art Publishers Association, 2001. http://apa.pmai.org/readall/summary2000.html (Accessed: December 10, 2004).

Spiegler, Marc. "Psst! Electronic Art: Will digital editions become the art world's new headache?" *Slate,* November 23, 2004, http://slate.msn.com/id/2109908 (Accessed: December 22, 2004).

Spiegler, Marc. "Too many galleries, not enough art." *The Art Newspaper*, February 2004. http://www.theartnewspaper.com/news/article.asp?idart=11588 (Accessed: December 21, 2004).

Stein, Gertrude. "Sacred Emily" (1913). In Gertrude Stein. *Geography and Plays*. Boston, MA: Four Seas Co., 1922, pp. 178-188. Reprinted by the University of Nebraska Press, 1993.

Steiner, Ina. "Sotheby's Holdings Releases Year 2001 Financial Results." *AuctionBytes.com*, March 13, 2002. http://www.auctionbytes.com/cab/abn/y02/m03/i13/s02 (Accessed: December 20, 2004).

Stork, David G. "Optics and realism in Renaissance art." *Scientific American*, Vol. 291, No. 6, December 2004, pp. 76-84. http://www-psych.stanford.edu/~stork/SciAmFinal.pdf (Accessed: January 30, 2005).

Szántó, András, Editor, et al. *Reporting the Arts II: News Coverage of Arts and Culture in America*. New York, NY: Columbia University National Arts Journalism Program, 2004. http://www.najp.org/publications/research/reporting2/chapters.htm (Accessed: January 31, 2005).

Szántó, András, Editor, et al. *The Visual Art Critic: A Survey of Art Critics at General-Interest News Publications in America*. New York, NY:

Columbia University National Arts Journalism Program, 2002. http://www.najp.org/publications/research/visualart/images/tvac.pdf (Accessed: February 1, 2005).

Tatchell, Jo. "Together in electric dreams." The Guardian, January 17, 2005. http://www.guardian.co.uk/print/0,3858,5104719-110428,00.html (Accessed: February 4, 2005).

Taylor, Andrew. "Taking brand placement to a whole new place." *The Artful Manager*, January 12, 2005. http://www.artsjournal.com/artfulmanager/94392.php (Accessed: January 28, 2005).

The Economist. "Music's brighter future." *The Economist*, October 28, 2004. http://www.economist.com/business/displayStory.cfm?story_id=3329169 (Accessed: February 4, 2005).

Tompkins, Joshua. "When Technology Imitates Art." *The New York Times*, July 22, 2004. http://tech2.nytimes.com/mem/technology/techreview.html?oref=login&res=9D02E6DC1E3AF931A15754C0A9629C8B63 (Accessed: January 18, 2005).

Towse, Ruth. "Cultural Economics, Copyright and the Cultural Industries." In Ernst, Halbertsma, Janssen and Ijdens, editors. *The Long Run*. Rotterdam: Barjesteh and Company, 2002. http://www.lib.uni-corvinus.hu/gt/2000-4/towse.pdf (Accessed: February 8, 2005).

Trebay, Guy. "Artists Stage a Be-In at Bergdorf's. *The New York Times*, October 26, 2004, p. B9. http://query.nytimes.com/gst/abstract.html?res=F30D15F83C590C758EDDA90994DC404482&incamp=archive:search (Accessed: October 28, 2004).

Tresser, Tom. "Creating Candidates Who Will Love and Respect the Arts." Pittsburgh, PA: National Performing Arts Convention, 2004. http://www.creativeamerica.us/06links.html (Accessed: February 3, 2005).

U.S. Census Bureau. *1997 Economic Census.* Washington, DC: U.S. Department of Commerce, 2001. http://www.census.gov/epcd/www/econ97.html (Accessed: December 10, 2004).

U.S. Census Bureau. *Census 2000 Summary File 3, Matrices H26, H27, H40, and H42 (QT-H8: Rooms, Bedrooms, and House Heating Fuel)*. Washington, DC: U.S. Department of Commerce, 2000. http://factfinder.census.gov/servlet/QTTable?_bm=y&-geo_id=01000US&-qr_name=DEC_2000_SF3_U_QTH8&-ds_name=DEC_2000_SF3_U&-_lang=en&-redoLog=false&-_sse=on (Accessed: December 10, 2004).

Union for Radical Political Economics. "Introduction: Art and Political Economy." *Review of Radical Political Economics*, Vol. 36, No. 4, 2004; pp. 461-470. http://rrp.sagepub.com/content/vol36/issue4/ (Accessed: February 4, 2005).

Unity Marketing, *2001 APA Art and Wall Décor Purchasers Survey: Mini Report*. Jackson, MI: Art Publishers Association, 2001. http://apa.pmai.org/readall/APAArtWallDecor.pdf (Accessed: December 10, 2004).

Unity Marketing, *2003 APA Art and Wall Décor Purchasers Survey: Mini Report*. Jackson, MI: Art Publishers Association, 2003. http://apa.pmai.org/2003_decor_survey.htm (Accessed: December 10, 2004).

University of Iowa. "The Facts of Life: Examining Reproductive Health. The History of Childbirth." *University of Iowa Medical Museum*, September 19, 2002. http://www.uihealthcare.com/depts/medmuseum/galleryexhibits/factsoflife/childbirth/history.html (Accessed: February 4, 2005).

Unwin, George, Unwin, Philip Soundy, and Tucker, David H. "History of Publishing." *Encyclopædia Britannica*. 2004. http://www.britannica.com/eb/print?tocId=9109461&fullArticle=true (Accessed: December 15, 2004).

Veiga, Alex (Associated Press). "U.S. album sales up 5.8 percent in first nine months of 2004." *Kentucky.com*, October 06, 2004. http://www.kentucky.com/mld/kentucky/9852630.htm?template=contentModules/printstory.jsp (Accessed: December 13, 2004)

Wachowski, Larry and Wachowski, Andy, Directors. *The Matrix*. Warner Brothers, 1999. http://bellarmine.lmu.edu/~jkasmith/phil160/matrix.txt (Accessed: December 11, 2004).

Walker, Leslie. "A New Mart for Original Art." *The Washington Post*, July 8, 2004, p. E1. http://www.washingtonpost.com/wp-dyn/articles/A33935-2004Jul7.html (Accessed: January 24, 2005).

Walker, Leslie. "Tuning to a New Arts Channel." *The Washington Post*, October 23, 2003. http://www.galleryplayer.com/press_turningto.aspx (Accessed: January 7, 2005).

Warhol, Andy. In Kynaston McShine, ed. *Andy Warhol: A Retrospective*. New York, NY: The Museum of Modern Art, 1989, p. 457.

Wark, McKenzie. *A Hacker Manifesto*. Cambridge, MA: Harvard University Press, 2004. http://subsol.c3.hu/subsol_2/contributors0/warktext.html (Accessed: January 28, 2005).

Webb, Cynthia L. "Musicians Sing Different Tune on File Sharing." *The Washington Post*, December 6, 2004. http://www.washingtonpost.com/wp-dyn/articles/A39155-2004Dec6.html (Accessed: December 13, 2004).

Webster, Edward. *Print Unchained: Fifty Years of Digital Printing, 1950-2000 and Beyond; A Saga of Invention and Enterprise*. West Dover, VT: DRA of Vermont, Inc., 2000.

White, Ben. "Wall Street Lends Its Style to Artists In Need of Funds." *The Washington Post*, June 30, 2004. http://www.washingtonpost.com/ac2/wp-dyn/A16045-2004Jun29? (Accessed: December 21, 2004).

Williams, Alex and Dash, Eric. "At Celebrity Nuptials to Die For, Vendors Give Themselves Away." *The New York Times*, January 13, 2005, p. A1. http://query.nytimes.com/gst/abstract.html?res=FB0E10FA3C5C0C708DDDA80894DD404482&incamp=archive:search (Accessed: January 24, 2005).

Wisniowski, Marie-Therese. *Not In My Name*. Newcastle, Australia: University of Newcastle, May 2003. http://www.pnp.org.au/pics/Columns/ART321_38.pdf (Accessed: December 16, 2004).

Witcombe, Christopher L.C.E. "What is Art…? What is an Artist…?" Sweet Briar, VA: Sweet Briar College Department of Art

History, 1997. http://www.arthistory.sbc.edu/artartists/artartists.html (Accessed: December 10, 2004).

Wolf, Bryan. "Confessions of a Closet Ekphrastic: Literature, Painting and Other Unnatural Relations." *Yale Journal of Criticism*, 3, 1990, pp. 181-203.

World Wide Arts Resources. "Company Facts." Absolutearts.com, 2005. http://wwar.com/ads/facts.html (Accessed: January 29, 2005).

Wyckoff, Elizabeth. "Matrix, Mark, Syntax." In David Platzker and Elizabeth Wyckoff. *Hard Pressed: 600 Years of Prints and Process*. New York, NY: Hudson Hills Press, 2000.

Wypijewski, JoAnn, Editor. *Painting by Numbers: Komar and Melamid's Scientific Guide to Art*. New York, NY: Farrar Straus Giroux. http://www.diacenter.org/km/ (Accessed: February 4, 2005).

www.ingramcontent.com/pod-product-compliance
Lightning Source LLC
Chambersburg PA
CBHW061440180526
45170CB00004B/1497